Aestheticism

A Selective Annotated Bibliography of

Dissertations and Theses

Elizabeth J. Hester

Copyright © 2014 Elizabeth J. Hester

All rights reserved.

No part of this book may be used or reproduced in any manner whatsoever without the written permission of the author.

Hester, Elizabeth J.

Aestheticism: A selective annotated bibliography of dissertations and theses/Elizabeth J. Hester

p. cm.

1. Aestheticism- -- Criticism and Interpretation. 2. Aesthetic Movement (Art). 3. Aestheticism (Literature). I. Title.

NK 1175

709/.03

ISBN 1500842087

ISBN-13 978=1500842086

Table of Contents

1.) **Agnew, L. P.** 1
The art of common sense: Victorian aestheticism and the rhetorical tradition.

2.) **Albin, D. D.** 4
Making the body (w)hole: A qualitative study of body modifications and culture.

3.) **Anderson, A. C.** 6
The High Art Maiden: Edward Burne-Jones and the girls on the Golden Stairs. Women and British aestheticism c. 1860-1900.

4.) **Anderson, A. S.** 10
William James Neatby: artist and designer 1860-1910.

5.) **Ascunce, A.** 13
The Avant-Garde spirit in Spain: Poetry? Politics? Art? Protagonists? Press.

6.) **Aveilhe, T. C.** 15
Art for the sake of life: The tension between aesthetics and social consciousness in fin de siecle periodicals.

7.) **Benson, P. F.** 18
Pre-Raphaelites: the first decadents.

8.) **Blanchard, M. W.** 21
Oscar Wilde's America: The Aesthetic Movement and the hidden life of the Gilded Age, 1876-1893.

9.) **Bohandy, S. R.** 24
Poetry set to music in Greece after the Civil War.

10.) **Brown, K. N.** 27
Revolutionary divas and the emergence of the decolonized text: Black women's subjectivity, images and ideologies (1970--present).

11.) **Cauti, C.** .. 30
The revolt of the soul: Catholic conversion among 1890s London aesthetes.

12.) **Cohen, J. A.** 33
The Queen Anne and the Late Victorian townhouse in Philadelphia, 1878-1895.

13.) **Collins, M. L.** 36
Suggestive silences: Sexuality and the aesthetic novel.

14.) **Conroy, C.** 39
"He hath Mingled with the Ungodly": The Life of Simeon Solomon after 1873, with a Survey of the Extant Works.

15.) **Coombs, D. S.** 43
Uncommon sense: Aesthetics, liberalism, and late Victorian cognitive science.

16.) **Cortes, A. d. J.** 46
Student idealists and the specter of natural science, 1870--1910.

17.) **Deakin, W. G.** 50
Recognition and romantic hermeneutics: Hegel and the English romantic tradition.

18.) **Denney, C. J.** 54
Exhibition reforms and systems: The Grosvenor Gallery, 1877-1890. (Volumes I and II).

19.) **Deusner, M. B.** 57
A network of associations: Aesthetic painting and its patrons, 1870--1914.

20.) **Deutsch, A.** 61
George Christian Gebelein: The craft and business of a modern Paul Revere.

21.) **Dickie, C.** 63
Representing dance: Early modern dance and modernist women's writing, 1880--1940.

22.) **Fischer, C. K.** 66
Thomas Jeckyll, James McNeill Whistler, and the "Harmony in Blue and Gold: The Peacock Room": A re-examination.

23.) **Friedman, D. E.** 69
Erotic Negativity and Victorian Aestheticism, 1864--1896.

24.) **Gaggin, J. R.** 72
Hemingway and Aestheticism (Decadence).

25.) **Gourianova, N.** 75
The early Russian avant-garde, 1908--1918: The aesthetics of anarchy.

26.) **Gregorich, C. L.** 78
H. Siddons Mowbray: "The Crystal Gazers".

27.) **Grimstad, K. J.** 80
Ancient heresy in modern literature: Gnosticism, aestheticism, and Thomas Mann's "Doctor Faustus".

28.) **Hayes, A. L.** 83
Kitten has claws: The feminine, the feline, and the threat of the New Woman in Cecilia Beaux's "Sita and Sarita".

29.) **Heath, L. M.** 86
John Ruskin and Greek art.

30.) **Jespersen, J. K.** 89
Owen Jones's "The Grammar of Ornament" of 1856: Field theory in Victorian design at the mid-century (Britain).

31.) **Jung, J. A.** ... 91
The Diva at the fin-de-siecle.

32.) **Katsan, G. M.** 94
Unmaking history: Postmodernist technique
and national identity in the contemporary
Greek novel.

33.) **Kent-Drury, R. M.** 97
Authority and landscape in Alexander Pope's
"Eloisa to Abelard".

34.) **Kim, H.** ... 98
Objects and knowledge: A historical
perspective on American art museums.

35.) **Krumrey, A.** 101
The notion of aestheticism in the works of
Oscar Wilde and Hugo von Hofmannsthal with
special reference to Salome and Elektra.

36.) **LaVigne, M.** 104
Rhetorical moves: Pursuing the Potential for
Movement in the Arts of Rhetoric and Dance.

37.) **Leck, R. M.** ... 107
Georg Simmel and the soul of German culture,
Geist-Politik: Fin-de-siecle to the Great War.

38.) **L'Enfant, J. C.** 110
Truth in art: William Michael Rossetti and
nineteenth-century realist criticism.

39.) **Lindberg, A. L. C.** 113
Konstpedagogikens dilemma: Historical roots and contemporary strategies.

40.) **Losa, M. L.** .. 116
From realist novel to working-class romance: An introduction to the study of the Brazilian, Italian, and Portuguese new social realist novel, 1930-1955, in light of new critical theory on realism, fiction, and reader response.

41.) **Mackie, G. P.** 119
Oscar Wilde and the moral imagination.

42.) **Mahoney, K. M.** 121
Appreciation and innovation: History and economics in late-Victorian aestheticism.

43.) **Masaki, T.** 124
A history of the toy book: the aesthetic, creative, and technological aspects of Victorian popular picture books through the publications of the firm of Routledge 1852-1893.

44.) **Maybee Reagan, L. M.** 127
Literature, drama and film about the Vietnam War: Postmodern and postcolonial perspectives.

45.) **McDowell, K. R.** 130
The reemergence of medieval word-weaving in Sasha Sokolov's "Shkola dlia durakov": Invoking the word.

46.) **McLauchlin, V.** 133
Aestheticism in British architecture: an analysis of the relation between idea and form in the late nineteenth century.

47.) **Meltzer, E.** 136
Art after words: Conceptualism, structuralism, and the dream of the information world.

48.) **Mendelssohn, M.** 139
Henry James and Oscar Wilde: a study of their literary relationship.

49.) **Meyers, C. K. B.** 142
Aestheticism and the "Paradox of Progress" in the work of Henry James, Edith Wharton, and Henry Adams, 1893-1913.

50.) **Meyers-Riczu, J. F.** 145
The re-creation of the Byronic hero in the music of Berlioz, Schumann, and Verdi.

51.) **Miller, M. J.** 147
Sympathetic Constellations: Toward a Modernist Sympathy.

52.) **Montgomery, D. L.** 153
William Powell Frith (1819-1909): A reevaluation of his artistic career.

53.) **Mortensen, P.** 156
High romantics and horrid mysteries: British literature and the struggle with German romance (1798-1815).

54.) **Murphy, J. G.** 159
Brook Hill, 1839-1895: A Virginia villa and its Aesthetic Movement art.

55.) **Nayak, S.** 161
Citizens everywhere: Modernism, decolonization, and discourses of citizenship.

56.) **Oldford, L.** 164
The art of socialism: William Morris and the Kelmscott Chaucer.

57.) **Ono, A.** 166
Japonisme in Britain - source of inspiration: J. McN. Whistler, Mortimer Menpes, George Henry, E. A. Hornel and nineteenth century Japan.

58.) **Ovnick, M. W.** 169
The arts and the craft of persuasion: Developing a language of reform. Los Angeles political and national aesthetic reforms, 1900--1916.

59.) **Ozturk, T. A.** 172
Ezra Pound and visual art.

60.) **Papalas, M. L.** 175
A changing of the guard: The evolution of the French avant-garde from Italian Futurism, to Surrealism, to Situationism, to the writers of the literary journal "Tel Quel".

61.) **Paulson, E.** 178
Farthest away, deepest within.

62.) **Pendleton, M. B. L.** 180
Bedford Park: An introduction to further study.

63.) **Potolsky, M. D.** 183
Teaching decadence: Aestheticism and the ends of education in Gautier, Masoch, and Pater.

64.) **Potts, S. W.** 185
F. Scott Fitzgerald: His career in magazines.

65.) **Poueymirou, M. L. R.** 189
The sixth sense: synaesthesia and British aestheticism, 1860-1900.

66.) **Primamore, E.** 191
The invention of "Michael Field": A dandy-androgyne, modernism and the aesthetic world of Katherine Bradley and Edith Cooper.

67.) **Pysnik, S.** .. **194**
Camp Identities: Conrad Salinger and the Aesthetics of MGM Musicals.

68.) **Reed, C. G.** .. **196**
Re-imagining domesticity: The Bloomsbury artists and the Victorian avant-garde. (Volumes I and II).

69.) **Roberts, E. E.** ... **198**
Japanism and the American aesthetic interior, 1867--1892: Case studies by James McNeill Whistler, Louis Comfort Tiffany, Stanford White, and Frank Lloyd Wright.

70.) **Ronchetti, A. L.** ... **201**
The artist-figure, society and sexuality in Virginia Woolf's novels.

71.) **Sattaur, J.** .. **204**
Representations of childhood: motifs of child and trickster in selected mid-Victorian to fin de siècle prose fiction.

72.) **Shaup, K. L.** .. **207**
Disciplining the senses: Aestheticism, attention, and modernity.

73.) **Spurgeon, J. L.** ... **209**
Western aesthetics and avant-garde trends in the formation of modern nihonga.

74.) **Srivastava, S.** 212
Fashioning the decorative body in late nineteenth-century English and French painting: Artifice, color and style.

75.) **Sultanian, M. P.** 215
Martha Graham engages the body and its dances as a path into the unconscious.

76.) **Susser, E. A.** 218
Modern selves/Romantic souls: The aestheticism of Pater, Wilde, and Yeats.

77.) **Sussman, M. B.** 221
Stylistic Virtue in Nineteenth-Century Fiction.

78.) **Sweeney, M.** 224
Hiding Genre Distinctions and Finding Gender Divides: An Iconographic, Formal, and Contextual Analysis of James Tissot's "Hide and Seek".

79.) **Thomson, J. W.** 226
From aestheticism to the modern movement: Whistler, the artists' colony of St. Ives and Australia, 1884--1910.

80.) **Truax Yarger, C.** 228
Louis H. Sullivan: The Aesthetic Movement, Classical Monumentality and the Skyscraper.

81.) **Wahl, K.** .. 230
Fashioning the female artistic self: Aesthetic Dress in nineteenth-century British visual culture.

82.) **Wark, J. M.** .. 233
The radical gesture: Feminism and performance art in the 1970s.

83.) **Watson, S. C.** .. 236
Servant of beauty: Willa Cather and the Aesthetic movement.

84.) **Weiner, H.** ... 238
The doctrine of the image: An analysis of Pound's Imagisme and its bipolar aesthetic of the image.

85.) **Weninger, S.** ... 240
The contagion of life: Rossetti, Pater, Wilde, and the aestheticist body.

86.) **Yount, S. L.** ... 243
"Give the people what they want": The American aesthetic movement, art worlds, and consumer culture, 1876-1890.

87.) **Yu, T.** .. 245
The sociology of the avant-garde: Politics and form in language poetry and Asian American poetry.

88.) **Zuelsdorf, D. L.** 248
Implications of creativity, artistic expression, and psychological cohesion: The self-portrait as a reparative selfobject of Egon Schiele.

Locating Dissertations and Theses 253

1.) **Agnew, L. P.**
The art of common sense: Victorian aestheticism and the rhetorical tradition.
Ph.D. dissertation, Texas Christian University. 1999.

The Victorian aesthetic movement generated a public discussion of art that offered a sense of shared values in the midst of social instability. The leaders of the aesthetic movement identified art as a concrete embodiment of the cultural ideal. Their critical writings about the importance of artistic production and appreciation demonstrate a wide range of opinions about how society can benefit from the visual and literary arts. Although Victorian aestheticism is essentially diverse, its advocates are generally united in their conviction that humans inherently possess the ability to appreciate art and that society benefits as individuals develop their critical judgment. The aesthetic movement's powerful arguments regarding the merit of art and criticism has led to the assumption that the principles of aestheticism are grounded in the

study of literature as we know it today. This perspective on the aesthetic movement has limited our understanding of its philosophical underpinnings and has underestimated the power of the rhetorical tradition in shaping the evolving consciousness of Victorian society. Situating the aesthetic movement within the British rhetorical tradition simultaneously expands our insight into the aesthetic movement and sheds light on a missing chapter in the history of rhetoric. Although the disparate strains of aestheticism defy categorical statements about the essential purpose of the aesthetic movement in Britain, it coalesces around a series of powerful statements about the relationship among individual expression, artistic production and criticism, and society. These statements, issued for public deliberation in the speeches and writings of prominent figures such as Thomas Carlyle, John Ruskin, William Morris, E. S. Dallas, Matthew Arnold, Walter Pater, Vernon Lee, and Oscar Wilde, reflect a unifying strain in the aesthetic movement--an interrogation of the

relationship between ethics and expression that is continuous with the rhetorical tradition. Examining the aesthetic movement within a broader historical and philosophical context illuminates its rhetorical foundation and demonstrates the strong relationship that existed among British rhetoric, literature, and the fine arts throughout the nineteenth century. [Author Abstract]

2.) **Albin, D. D.**
Making the body (w)hole: A qualitative study of body modifications and culture.
Ph.D. dissertation, The University of Texas - Austin. 2001.

This project examines the psychodynamics of sexuality, ritual, culture and identity as they relate to the use of the physical body. Because the corporeal is situated at the point of intersection where expressions of sexuality and cultural boundaries meet, the body has become a central concern both in academia and the wider culture, providing one of the few points of direct contact between these often divorced spheres. In this project, theoretical debates concerning the body and its socio-cultural functions and uses are highlighted and integrated with the practices of body modifications. Focusing on the meaning of these practices, five types of modifications are explored through qualitative and semiotic methods. Twenty subjects were interviewed, with analyses integrating current media

impingements and the resulting actions of individuals. In particular, body piercings, tattoos, self-mutilation, cosmetic surgery and eating disorders all form part of American culture's obsession with corporeal malleability and the body as a form of adornment. These modification practices are part of a widespread contemporary aesthetic movement that incorporates dynamics involving identity formation and expression. Bounded by the rules that govern aesthetic convention, no other human activity is more closely paired with the psychodynamics of sexuality that personal adornment. Such practices are part of the poetics of the mind-body experience that organizes individual and collective lives. That the body can be read as a text is asserted with evidence of how individual narratives are generated through the body. [Author Abstract]

3.) **Anderson, A. C.**
The High Art Maiden: Edward Burne-Jones and the girls on the Golden Stairs. Women and British aestheticism c. 1860-1900.
Ph.D. dissertation, University of Exeter (United Kingdom). 2001.

The principal aim of this thesis is to investigate the impact of Aestheticism on British women during the period c. 1860-1900. From the 1870s, poets, painters and the press were obsessed by the female aesthete. The Aesthetic movement had its roots in the 1850s and had evolved by the 1880s into a movement without a formal manifesto or a particular institution to represent it. Oscar Wilde became an informal spokesman for the movement, which included an appreciation of the poetry of Keats, Swinburne and Rossetti, the paintings of the Pre-Raphaelites, an enthusiasm for japonisme as well as for the craftsmanship of William Morris & Co. Women were to play a significant part in the movement, as both consumed and consuming subjects but the press was divided about the

effects of Aestheticism on women and society as a whole. Under the influence of the 'Cult of Beauty' and aesthetic taste a new feminine ideal evolved, described in 1882 by Walter Hamilton in The Aesthetic Movement in England, as 'a pale distraught lady with matted dark auburn hair falling in masses over the brow, shading eyes full of love-lorn languor, or feverish despair...long crane neck, flat breasts, and long thin nervous hands'. Mrs Haweis attributed the new type, seen to be at best unattractive and at worst ugly, to Rossetti and Burne-Jones. Quilter and Wedmore accused the paintings of Rossetti and Burne-Jones of spreading disease, decay and corruption. The same source was blamed for the adoption of loosely flowing, vaguely medievalising, and apparently non-corseted robes by the female aesthetes. The slouching, 'boneless', posture, or droop, and look of dejection completed the look seen in pictures. This thesis seeks to explain what prompted women to enact Pre-Raphaelite paintings in actual life. It also seeks to understand why this

mimetic attraction was viewed both positively and critically by Victorian society and to demonstrate the gap between the 'ideological projection and social praxis'. The wan female aesthete, who appeared in daily life with the characteristic slouch and oddly coloured garments, accompanied by beautiful 'arty' things, suggested that being surrounded by the exquisite could be both enlightening and ennobling. By dressing the right way and having the right things one could demonstrate one's 'natural nobility'. This came at the height of the cult of the nobility by the middle classes. The thesis hopes to make an original contribution to the understanding of later Victorian society through its analysis of the activities of female aesthetes, as practicing artists, consumers and the providers of art education to the working classes. It offers alternative viewpoints of the impact of Aestheticism, not just in terms of the debates surrounding gender and sexuality, but also in terms of fashion, artistic taste in interior decoration and collecting and attitudes to

education and social reform. The thesis revises the role of the amateur artist, and her contribution to the contemporary art world, through her exhibiting and the selling of works for charitable causes. It looks at areas of female participation that have not been fully explored before, such as the annual Amateur Art Exhibition, China Painting Exhibitions at Howell and James and the founding of improving and educational organisations such as the Kyrle Society and the Home Arts and Industries Association. [Author Abstract]

4.) **Anderson, A. S.**
William James Neatby: artist and designer 1860-1910.
Ph.D. dissertation, De Montfort University (United Kingdom). 2000.

The principal aim of this thesis is to investigate the life and work of William James Neatby (1860-1910), artist and designer. Neatby worked as a designer, largely of architectural ceramics, during the 1880s and 1890s. After the turn of the century he became a more general designer, working in a variety of media. Several of his works are extant and, of these, the tile interior of the Meat Hall in Harrods department store, London, and the ceramic facade of the Everard Printing Works, Bristol, are the best known. The thesis investigates his early life and training, his career as a designer at the Burmatofts ceramics works, Leeds, and subsequently as Head of the Architectural Ceramics Department at Doulton of Lambeth. Finally, the study looks at his life as an

independent designer in the years 1901-1910. On a broader front the thesis establishes the charter of Neatby's achievements, analysing his design philosophy, relating it to other contemporary artistic ideas and movements. In doing so it re-evaluates the nature and achievements of fin-de-siècle art in Britain and where appropriate in Europe. This section of the thesis also reappraises certain terms and design systems relating to contemporary art and design movements in Britain and Europe. In particular, the terms 'Art Nouveau', 'Arts and Crafts' and 'Aesthetic Movement' are scrutinised and re-defined or deconstructed in the light of this research programme. The thesis makes an original contribution to knowledge of the late Victorian and Edwardian art and design world through its analysis of Neatby's work in relation to that of his contemporaries, offering alternative viewpoints, to those usually promoted, on the relationship of the Arts and Crafts Movement to

the Aesthetic Movement and the origins of the English New Art Style. The thesis also discusses and illustrates several areas of Neatby's work that have not been published before, allowing for a re-appraisal of his status as an artist and designer in the period 1880-1910. [Author Abstract]

5.) **Ascunce, A.**
The Avant-Garde spirit in Spain: Poetry? Politics? Art? Protagonists? Press.
Ph.D. dissertation, University of Virginia. 2007.

This dissertation is about the relationship between Barcelona and Madrid from the onset of Futurism (1909) to the first major signs of Surrealism (1929) in Spain. It is the first work of its kind since, traditionally, the story of the Historical Avant-Garde in Spain has only been told from the point of view of Barcelona or Madrid. This dissertation is different from all the other studies to treat this moment in history in that it takes both cities into account simultaneously. This research project also distinguishes itself from all others related to the Historical Avant-Garde in that it also accounts for politics, art, poetry, the press, and its protagonists at the same time. After consulting nearly one hundred artistic and literary magazines from the period, and a variety of other primary and secondary sources, my research proves that the relationship between

Barcelona and Madrid during this historical moment was much more dynamic and connected than we have been led to believe. Furthermore, my evidence shows that more than any other cultural or aesthetic movement of the nineteenth and twentieth-century Spain, the Historical Avant-Garde united Barcelona and Madrid in a way that is without precedent. That which brought these two cities, and their respective avant-garde movements, closer together was a shared belief in the ideals espoused by this cultural phenomenon that spanned from approximately 1906 to 1936 in Spain. This avant-garde spirit was one that transcended all material boundaries and, in turn, resulted in the production of some of the most revolutionary works of modern art and literature still influential today. [Author Abstract]

6.) **Aveilhe, T. C.**
Art for the sake of life: The tension between aesthetics and social consciousness in fin de siecle periodicals.
Ph.D. dissertation, The University of Tulsa.
2012.

This dissertation examines how tensions that arose out of the perceived separation of art and life during the late nineteenth century - specifically, out of the separation of aesthetics and social consciousness - are contemplated and worked through in the visual and literary contents fin de siècle periodicals. Aesthetic periodicals (artistic and literary publications typically connected to Aestheticism and Decadence) produced both aesthetic and social meaning in their efforts to address the art-life tension. Three fin de siècle periodicals which explore this dichotomy in distinctive ways are examined: The Woman's World (British, 1887-1890), The Yellow Book (British, 1894-1897), and The Lark (American, 1895-1897). This study contends that these fin de siècle aesthetic

periodicals produced three separate strategies for addressing the tension between aesthetics and social consciousness: synthesis, division, and displacement. These terms provide a conceptualization of the ways in which discourses on Aestheticism and Decadence encountered discourses on socio-historical awareness, interdependence, and communality, as well as the ways in which competing positions were worked through by means of aesthetic experimentation within the pages of the periodicals. Chapter One provides historical and theoretical groundwork for the chapters that follow, sketching out the essential elements of nineteenth-century periodical history. This chapter contextualizes the emergence of the aesthetic periodical in Europe and America and its convergence with the Aesthetic Movement and nineteenth-century aesthetic philosophy. Chapter Two focuses on the London-based periodical The Woman's World and examines its cultivation of a woman-centered form of aestheticism based on a synthesis of aesthetic

sensitivity and socio-historical consciousness. Chapter Three looks at The Yellow Book, arguing that the journal records divisions between aesthetes who embraced aestheticism as an alienating, subjective practice and those who saw aesthetic experience as an opportunity for interdependence between artists, viewers, and readers. Chapter Four examines the American little magazine The Lark. I argue that by using the strategy of displacement, The Lark attempts to reassert the primacy of "real" experience over aesthetic experience. Through its association with bohemianism, The Lark's editors were able to formulate an artistic counter-community that valued nature, humor, and communality. [Author Abstract]

7.) **Benson, P. F.**
Pre-Raphaelites: the first decadents.
Ph.D. dissertation, University of North Texas. 1980.

The ephemeral life of the Pre-Raphaelite Brotherhood belies the importance of an organization that grows from and transcends its originally limited aesthetic principles and circumscribed credo. The founding of the Pre-Raphaelite Brotherhood in 1848 really marks the beginning of a movement that metamorphizes into Aestheticism/Decadence. It is the purpose of this dissertation to demonstrate that, from its inception, Pre-Raphaelitism is the first English manifestation of Aestheticism/Decadence. Although the connection between Pre-Raphaelitism and the Aesthete/Decadent movements proposed or mentioned by several writers, none has written a coherent justification for the viewing of Pre-Raphaelitism as the starting point for English Decadence. This dissertation attempts to establish the primacy of Pre-Raphaelitism in the development of

Aestheticism/Decadence. Despite the comments of such late nineteenth and twentieth century writers as Wilde, Yeats, Pater, Symons, and F. W. H. Myers, who all support the notion of the Pre-Raphaelitism--Aestheticism/Decadence continuum, the theory loses popularity after the First World War, and it is rare to find any writers or critics who come forth to make a case for the connection between Pre-Raphaelitism and Aestheticism/Decadence. For the most part critics deal with the two movements as separate phenomena. The occasional exceptions to the rule have not really violated it. For example, Lord David Cecil's statement that Rossetti "is indisputably the representative man of the Aesthetic movement..." is from a discussion about Rossetti as an individual artist. Cecil deals with Rossetti's later career and ideas as essentially separate from his earlier Pre-Raphaelite association. Although a host of critics including Jerome Buckley, D. S. R. Welland, William Fredeman, Charles Spencer, Ruth Child, and several others, directly deny the

development of Aestheticism/Decadence from Pre-Raphaelitism, a justification in this dissertation is built on a detailed analysis of the three phases of Pre-Raphaelite aesthetic growth. The primary contention is that embryonic Decadent ideas and concepts are present in Pre-Raphaelite thinking in the earliest phase of the movement (1848-1856) and are given birth by the Rossetti circle of Rossetti, Morris, Swinburne, and Burne-Jones during the second phase (1857-1862). Special emphasis is placed on Rossetti and Pater as the crucial links in the evolution of Pre-Raphaelite ideas into the Aesthete/Decadent credo of Wilde, Beardsley, Symons, and Keats. [Author Abstract]

8.) **Blanchard, M. W.**
Oscar Wilde's America: The Aesthetic Movement and the hidden life of the Gilded Age, 1876-1893.
Ph.D. dissertation, Rutgers University - New Brunswick. 1994.

To see Victorianism (or even Gilded Age America) as a monolithic, static category can be misleading. The Aesthetic Movement of the 1870's and 1880's, a popular art movement, was an episode in a larger dialectical process, a process toward modernity which pitted aesthetic and bohemian strains against other tendencies from the 1870's onward. Not an elite movement, Aestheticism contested middle-class domesticity, as women championed an artistic individuality over a maternal role and created alternate mind-worlds through opiates. For men, the emergence of the homosexual aesthete Oscar Wilde created latitude for some Victorian men to experiment with new gender identities. This dissertation

examines material culture as well as traditional texts. Artifacts in the aesthetic parlor, the artistic costume of aesthetic women, images in the popular media, as well as specific individuals involved with the Aesthetic Movement (Candace Wheeler, a textile designer, and Oscar Wilde), frame the argument. In a wider context, the analysis looks at the effect of two periods of militarization upon the Aesthetic Movement (the Civil War and the rise of imperialism in the 1890's), as well as the cultural battle between models of "manly" (and "soldierly") labor and the individual aesthetic ideal popularized by Wilde. In conclusion, the quasi-sacramental dimension of popular art, the alternative realities, and the critique of utilitarianism so pronounced in the Aesthetic ideology suggest a counter agenda for the Gilded Age. For identities were fluid and shifting as were perceptions of objects and spaces. Americans saw aesthetic artifacts, not always as consumer items or as emblems of

wealth and status (the conventional vision of Gilded Age society), but as part of a "hidden" aesthetic environment. The male aesthetic sensibility, so prominent in the Aesthetic decades, prompted a homosexual awareness that was apparent (and at times approved) in American popular culture during the 1870's and 1880's. [Author Abstract]

9.) **Bohandy, S. R.**
Poetry set to music in Greece after the Civil War.
Ph.D. dissertation, Boston University. 1998.

At the end of the 1950s, Greek artists and intellectuals faced a dilemma: by numerous accounts, art in Greece had arrived at a certain standstill. There was a widespread consensus that Greek poetry had become estranged from the broad public. Moreover, many agreed that Greek music was in a deplorable state. Nazi occupation and the Greek civil war in the 1940s had generated a volatile historical situation which signalled to a number of Greek artists the need for action, the imperative that they find a means of providing for a disoriented and demoralized Greek people guidance, leadership, direction, a sense of purpose and hope. In answer to this dilemma, they embraced the idea of setting poetry to music. Throughout the 1960s and 1970s, works of this genre flourished in Greece, both as an exciting aesthetic movement

and a mode of political expression. Part I of the dissertation, "The Situation," outlines the background of the circumstances that led many Greek artists and intellectuals at the end of the 1950s to feel compelled to find ways of bringing poetry to the people and of rejuvenating Greek music as a source of national pride and Greek identity. Part II, "Resources" offers a detailed discussion of the three major resources which Greek composers had at their disposal in seeking a solution to this dilemma: the idea of the traditional interrelationship of poetry and music in Greek culture, Greece's tripartite musical heritage, and music's expressive and political potential. Part III, "Epitaphios," is a detailed analysis of Mikis Theodorakis's composition by that name. Composed in 1958, this work marked a turning point in the history of Greek music, defining a new genre and setting a standard for subsequent composers. It is here considered in its historical, cultural and political context, with

special attention to its relation to Yiannis Ritsos's original poem. Drawing upon scholarly analysis, documents and oral testimonies, this dissertation offers an explanation of the particular interplay of environment, artists, art works, and audiences that initiated such a rich and politically resonant union of word and music in the Greece of the 1960s and 1970s. [Author Abstract]

10.) **Brown, K. N.**
Revolutionary divas and the emergence of the decolonized text: Black women's subjectivity, images and ideologies (1970--present).
Ph.D. dissertation, University of Maryland - College Park. 2002.

This project explores the cultural production of African American women between 1970 and the present in order to examine how these women create texts that can be labeled decolonized to a greater extent than their predecessors' texts. I define decolonization as the process by which African American creative artists attempt to disassociate black subjectivity from its connection to whiteness. I assert that the women in this study offer alternative models of black subjectivity that seek to transform their audiences into radical/revolutionary agents. Most contemporary scholarship continues to focus on W. E. B. Du Bois's concept of double-consciousness and the James Weldon Johnson-influenced notion of the structural doubleness of African American texts. These concepts are

problematic because they lead us to see African American texts from the perspective of a white gaze. Equally problematic is the continued preoccupation with the effect of whiteness on the black psyche, which hinders an analysis of the text in the context of its black audience. My project necessarily reevaluates the importance of the Black Aesthetic Movement by finally providing black audiences the attention they deserve. Documenting the contemporaneous development of black studies programs and black and Third World journals and publishing houses, I argue that the Black Aesthetic Movement was a defining moment in the history of African American culture. The Black Aesthetic Movement's primary initiative was the decolonization of black Americans, and as a result fostered a new collective black consciousness that privileged the black gaze. I posit the women analyzed in Revolutionary Divas as the successors of the Black Aesthetic Movement. I examine the extent to which each woman's text can be labeled "functional,

collective, and committed"--Maulana Karenga's definition of the Black Aesthetic. My assertion is that critics have ignored the indebtedness to Black Aesthetics that many contemporary African American women's writing reflects. Throughout the project, I demonstrate each woman's connection with the Black Aesthetic, as well as how each woman offers programs for revolution that extend beyond the sometimes essentialist and sexist limitations of Black Aesthetic ideology. [Author Abstract]

11.) **Cauti, C.**
The revolt of the soul: Catholic conversion among 1890s London aesthetes.
Ph.D. dissertation, Columbia University. 2003.

This dissertation explores the often critically neglected Roman Catholic conversion epidemic that swept through London's 1890s avant-garde--followers of the Aesthetic Movement who synthesized French Symbolism and Decadence with native English Pre-Raphaelitism and Celtic Twilight mythos. I examine the circumstances and writings (primarily poetry) of selected converts--Oscar Wilde, Ernest Dowson, John Gray, and the two writers (Katherine Bradley and Edith Cooper) who shared the pseudonym Michael Field. To complement and contextualize this phenomenon, I also discuss the related contemporary quest for esoteric mysticism as embodied in William Butler Yeats, himself not a convert to Catholicism but an indefatigable spiritual quester and commentator on the religion in an apocalyptic short-story trilogy from The Secret Rose. As its title (taken from Yeats)

suggests, this dissertation posits Catholic conversion in 1890s London as a subversive act; in exploring the seemingly paradoxical notion of subversive orthodoxy, however, the negative capability that permits the productive irreconciliation of Catholicism's own seeming paradoxes becomes of paramount importance. Although all part of the same creative milieu, each figure converted for different reasons, yet the writers' often heterodox subject matter and personal behavior--expressed variously via feminism, homosexuality, pedophilic eroticism, incest, or substance abuse--would seem to clash with such an authoritative, orthodox institution. After an introduction that provides background on the status of Roman and Anglo-Catholicism in late Victorian society and popular imagination (which simultaneously equated Catholic conversion with an essential feminization and demonization), I include a prelude on Wilde's deathbed conversion and lifelong flirtation with Catholicism, and his ironic reinventions of Gospel narratives. My first chapter focuses on Dowson's

"spiritually redeeming" attraction to female children, the second on the once-archetypal homoerotic dandy Gray's journey to the priesthood and his Decadent Pre-Raphaelitism. Bradley and Cooper's incestuous lesbian relationship influenced their Catholic mind-set, which valorized suffering and produced poems voicing and celebrating New Testament women's perspectives. The final chapter, on Yeats, aligns Freemasonry as a parallel yet socially sanctioned ritualistic operation, and contemporary interest in occult mysticism as a response to Catholicism's exoteric mysticism. [Author Abstract]

12.) **Cohen, J. A.**
The Queen Anne and the Late Victorian townhouse in Philadelphia, 1878-1895.
Ph.D. dissertation, University of Pennsylvania. 1991.

This study focuses on the design of townhouses in Philadelphia from the late 1870s to the mid 1890s. It explores the dramatic shifts in architectural values that emerged with the adoption of the Queen Anne Revival at the beginning of this period, and follows the remarkable transformation of that style after the mid-1880s. The urban domestic work of several architectural firms--those of Wilson Eyre, Frank Miles Day, R. G. Kennedy, Cope & Stewardson, A. J. Boyden, Brown & Day, and Hazlehurst & Huckel--receives particular attention, as they played a leading role in developing a distinctive brand of design in Philadelphia. Relatively little testimony regarding their intent survives from the time, but close observation of the exteriors and plans of their later 1880s townhouses reveals that, although they dismissed most of

Queen Anne's characteristic classical armature and redness, they retained much of that style's picturesque coherence, informality, and domesticity. They turned instead to more pronounced ahistoric effects inspired by the Aesthetic Movement, including a thinned architectural membering, the use of fluid line, balanced asymmetries, relatively unornamented surfaces, and a new, lighter palette. This work is identified here as Aesthetic Lyricism. Architectural journals, exhibitions, and local organizations, most notably the T Square Club, enhanced the interaction between these architects and spread their influence. This historical chapter drew to a close, however, in the mid-1890s, as the building of townhouses declined and these stylistic formulations were eclipsed by national trends toward a more academic historicism, typological legibility, and civic monumentality. In addition to looking more closely at the focal architect-designed townhouses, this study places them against the stylistic and urbanistic patterns of other buildings

in urban Philadelphia, and also against the backdrop of related stylistic expressions in other cities. There were occasional close analogues among Boston and New York townhouses by prominent firms, in several cases predating the Philadelphia work, but such self-consciously artistic design enjoyed a special flowering in Philadelphia. These townhouses, along with their Shingle Style suburban counterparts, were in many ways the central examples of Late Victorian architecture in the United States. [Author Abstract]

13.) **Collins, M. L.**
Suggestive silences: Sexuality and the aesthetic novel.
Ph.D. dissertation, Temple University. 2012.

This dissertation addresses how the philosophy, subculture, and sexuality of aestheticism interact with the form of the nineteenth-century novel. One primary result of this exploration is a nuanced delineation of the aesthetic novel in its formal characteristics, its content, and most notably, in the sexually charged silences that both this form and content reveal--silences made audible to invested aesthetic readers through coded doubleness. Through thus defining the aesthetic novel and seeking to articulate the unspoken sexual transgressions that are, as is argued, requisite therein, this project sheds new light both on the partially submerged sexuality of aestheticism as a movement, and on why novels account for so small a portion of the aesthetic movement's output--topics first raised in part by Linda Dowling, Dennis Denisoff, and Talia Schaffer. By engaging Oscar Wilde's The Picture

of Dorian Gray (1891), Vernon Lee's Miss Brown (1884), Walter Pater's Marius the Epicurean (1885), Robert Hichens' The Green Carnation (1894), John Meade Falkner's The Lost Stradivarius (1895), and Aubrey Beardsley's Venus and Tannhäuser (1895), this dissertation demonstrates that, whether politically engaged as affirmation or using sexuality as a way to communicate rejection of middle-class morality and its own fascination with the unusual, aestheticism defines itself by its inclusion of unusual sexual situations. This argument is in part guided by and grapples with theoretical writings by Victorian sources including Walter Pater, Matthew Arnold, and Walter Hamilton and contemporary sources including Alistair Fowler, Nancy Armstrong, and D. A. Miller. Central to the dissertation are the suggestive silences in aesthetic novels that function not merely as the unsaid, but appear at points that beg explanation or exploration, indicating the presence of the forbidden with the frisson between interest and absence. Such moments

form a pattern of mysterious sexual omissions in the novels of aestheticism, titillating audiences with their implied perversity, but never explicitly exploring it on account of legal, economic, and social censorship. Finally, this project shows that the unspeakable gaps in legal above-ground literature can easily be articulated within the already illegal world of pornography, which this dissertation accesses through the aesthetic and pornographic Teleny (1893). [Author Abstract]

14.) **Conroy, C.**
"He hath Mingled with the Ungodly": The Life of Simeon Solomon after 1873, with a Survey of the Extant Works.
Ph.D. dissertation, The University of York (United Kingdom). 2009.

This thesis focuses on the life and work of the marginalized British Pre-Raphaelite and Aesthetic homosexual Jewish painter Simeon Solomon (1840-1905) after 1873. This year was fundamental in the artist's professional and personal life, because it is the year that he was arrested for attempted sodomy charges in London. The popular view that has been disseminated by the early historiography of Solomon, since before and after his death in 1905, has been to claim that, after this date, the artist led a life that was worthless, both personally and artistically. It has also asserted that this situation was self-inflicted, and that, despite the consistent efforts of his family and friends to return him to the conventions of

Victorian middle-class life, he resisted, and that, this resistant was evidence of his `deviancy'. Indeed, for over sixty years, the overall effect of this early historiography has been to defame the character of Solomon and reduce his importance within the Aesthetic movement and the second wave of Pre-Raphaelitism. It has also had the effect of relegating the work that he produced after 1873 to either virtual obscurity or critical censure. In fact, it is only recently that a revival of interest in the artist has gained momentum, although the latter part of his life from 1873 has still remained under-researched and unrecorded. Therefore, the function of this thesis is to re-evaluate Solomon's life after his arrest in 1873 and reveal what actually happened to the artist during the final thirty-three years of his life. It does this primarily through a unique study and examination of newly identified archival documents and information. By examining, in particular, the original nineteenth-century

records that relate to his arrest in London, and those that record a virtually unknown arrest in Paris in 1874, and putting this in the context of nineteenth-century sodomy law and male homosexual society, it is possible to re-consider Solomon's previously misunderstood resistance to sexual and societal rehabilitation. It makes use of a new critical understanding, which now suggests the non-repentance of the previously seen tragic figure of the homosexual male in Victorian society, which was promoted in part by the Oscar Wilde trials of 1895. The study of the detail of Solomon's later life within this thesis will support these new ideas by promoting the suggestion of the artist as self-consciously queer and unapologetic. In addition, this thesis includes, for the first time, a survey of Solomon's works produced after 1873, which help to provide an approximation of how active Solomon was artistically; suggest what kind of media he

was using during certain periods; record who was continuing to buy Solomon's work at this time, and to make the images of Solomon's extant work available to future researchers. These extant images appear in Volume II of this thesis. [Author Abstract]

15.) **Coombs, D. S.**
Uncommon sense: Aesthetics, liberalism, and late Victorian cognitive science.
Ph.D. dissertation, Cornell University. 2011.

This dissertation argues that cognitive science emerges in the latter half of the nineteenth-century, transforming the relationship between aesthetic experience and political liberalism in the Victorian imagination. New scientific theories of sensory perception and cognition opened an intractable conflict between two liberal principles underlying Victorian notions of aesthetic experience--the commitment to autonomous agency and the necessity of a shared set of agreements about the world for democratic deliberation and debate. Through readings of literary and scientific texts, I argue that this conflict shapes Victorian conceptions of agency, ethics, and art, as well as several of the period's most important texts, events, and movements. Chapters 2 and 3 are case studies of how cognitive science shapes the aesthetic theories governing two major late Victorian novels.

Chapter 2, "Raising National Unconsciousness: Neural Writing and Sympathy in Daniel Deronda," argues that George Eliot draws from G.H. Lewes' description of consciousness as a palimpsest of neural pathways in order to conceive of sympathy as a means of rewriting the mind by reflectively reinterpreting experience. Chapter 3, "Reading in the Dark: Sensory Perception and Agency in The Return of the Native," reads Hardy's novel in the context of late Victorian psychological theories that characterize sensory perception as a form of interpretation analogous to reading. Chapters 4 and 5 analyze the role of cognitive science in the theories, debates, and controversies that defined the British Aesthetic Movement. Chapter 4, "Beautiful Graffiti: Vernon Lee, Wilhelm Dilthey, and the Democratization of Art" analyzes Lee's and Dilthey's parallel efforts to envision an aesthetic polity in which a perceptual sensus communis is forged and managed by the secret shaping hands of an artistic aristocracy. Chapter 5, "Unchained Harmony: Walter Pater's Ethics of

Influence," argues that Pater's writings after The Renaissance attempt to accommodate the ethical imperatives of common sense without sacrificing the teeming, unique sensory details that escape the perceptual norms guiding common sense experience. "Uncommon Sense" thus demonstrates the crucial role of cognitive science in late Victorian literature and culture, arguing for renewed attention to the ongoing dialogues between literature and science that promise the enrichment of both. [Author Abstract]

16.) **Cortes, A. d. J.**
Student idealists and the specter of natural science, 1870--1910.
Ph.D. dissertation, University of Notre Dame. 2008.

This dissertation examines the normative content of collegiate student intellectual life in art, literature, and philosophy during the period 1870-1910. This perspective allows for some precision concerning the nature of student thought at a time when, historians believe, a shifting curriculum provided an infertile terrain for moral instruction. Based on an extensive use of primary documents--especially essays written in student literary publications--I show how a segment of undergraduates I call idealists resisted natural science, its methods, and especially its application to the humanities: first, because they believed it would obscure certain principles that they wanted to see clearly; second, because they feared it would introduce a

post-Christian and thus an amoral world. My sources come from diverse institutions: Harvard, Wellesley, Princeton, Vassar, the University of California, and Smith. Chapter one describes the socioeconomic, religious, and educational backgrounds of students at these schools, so far as available. With this composite in place, I describe the larger intellectual context that shaped the thought of undergraduates. Chapter two considers late Victorian conceptions of art as expressed by cultural commentators, professors of art, and their students. I show how in the 1860s and 1870s collegians tended to treat art as a vehicle for religious instruction and ethical reflection. By the 1880s, the emergence of an Aesthetic Movement that subordinated moral content to the "art-technique," plus the influence of certain art historians, led students to apotheosize art, rather than treat it as a means to understanding something greater. In chapter three, I show how students' interest in exploring

normative conceptions in literature was challenged by an empirical hermeneutic that emerged in the 1880s as the legitimate form of textual analysis. While some idealists' "literary instinct" led them to reject the "scientific method" in literature, others, in their attempt to avoid it, were driven into a mystical literary experience. Led by some professors, student idealists turned the world of English letters into a romanticized space that functioned as a bulwark against the "Papacy of Science." In chapter four, I argue that the dread of natural science led some students to embrace Transcendentalism and reject Pragmatism. In chapter five, I demonstrate how students' sacralization of the humanities was intimately related to a narrowing understanding of science. As the humanities expanded in dealing with phenomena of "enduring significance," science underwent a severe contraction. For most of the nineteenth

century, science was a capacious term describing virtually any systematic and rigorous intellectual labor, such as that conducted in philosophy or theology. By the 1880s and 1890s the term commonly only described work in the "natural sciences." This dissertation describes how idealists responded to this development. [Author Abstract]

17.) **Deakin, W. G.**
Recognition and romantic hermeneutics: Hegel and the English romantic tradition.
D.Phil. dissertation, University of Sussex (United Kingdom). 2012.

In what follows I seek to articulate a romantic hermeneutics, that is, an interpretive approach to texts acknowledged as central to the canon of English Romanticism that articulates the human relationship to artistic creation, the natural world and metaphysics. Through this methodological approach I hope to integrate philosophy with the study of English Romanticism, and delineate a coherent, inter-disciplinary corpus of intellectual ideas, all of which can be subsumed under the rubric of "Romanticism"; Using this hermeneutical approach, I offer Hegel's teleological theory as an example of a romantic mythology; that is, a story that attempts to reintegrate the human subject into the natural world whilst at the same time retaining a sense of imaginative autonomy. I offer a reading of Hegel, which combines his social philosophy with

his philosophy of art, and integrate the two areas of his work using an expanded understanding of his notion of recognition. What motivates the philosophical approach to English Romanticism, and the use of Hegel as an exemplar of a romantic narrative, is the conviction that the English romantic tradition is philosophically rich in ways not always appreciated by traditional commentary. I posit a connection between seemingly disparate Romanticisms such as those of Wordsworth, Coleridge and the later P.B. Shelley. All of these thinkers and artists present us with varying forms of romantic mythology, each looking to retain a contingent, autonomous subjectivity, whilst retaining a necessary connection to the empirical world. Working on this assumption, I explicate these different romantic narratives, whilst illustrating the structural features common to them all. Central to my thesis is the idea that this philosophical-narratorial template gives the critic a useful hermeneutical reading tool with which to approach texts, which, whilst subsumed

under the generic category of Romanticism, offer contradictory conclusions in their treatment of artistic creation, nature and metaphysics. Of course, this is only one approach amongst many, and as such a romantic hermeneutics, that whilst not exhaustive, hopes to add to the other critical prisms through which Romanticism has been explicated as an aesthetic movement, or a substantive canon of texts. I contend that all the major canonical romantic poets covered here approach the problem of philosophical certainty through the romantic ideal that there is an intuitional assent to knowledge through aesthetics. Using a Hegelian approach as an interpretive guide is therefore useful in that Hegel endorses art as a way of apprehending philosophical certainty on the one hand, yet on the other places philosophy on a higher interpretive level. This means that in using Hegel we can gain a double-awareness of our subject matter; we see the strengths of art in its approximation of philosophical certainty, and we can critique it in terms of its relationship to

speculative philosophy, which acts as an alternative narrative for attaining philosophical certainty. I aim to argue in this thesis therefore that both the romantic poets and Hegel share a common romantic purpose, which is explored in their romantic mythologies. [Author Abstract]

18.) **Denney, C. J.**
Exhibition reforms and systems: The Grosvenor Gallery, 1877-1890. (Volumes I and II).
Ph.D. dissertation, University of Minnesota. 1990.

Although the Grosvenor Gallery, located at 135-137 New Bond Street, London, is often mentioned in the literature as a leading exhibition space for British and Continental artists during the late Victorian period, a complete study of its history has not been previously attempted. The owner and proprietor, Sir Coutts Lindsay (1824-1913), invited contributions from progressive artists of the day, often producing controversial results. The present study examines the spectrum of Summer exhibitions and the range of avant-garde artists, who included Burne-Jones and figures of the Aesthetic Movement; Bastien-Lepage and the Rustic Naturalists; the Newlyn School, and the Irish and London Impressionists; and the Glasgow Boys. Other scholars have

focused on the early years of the gallery, perceiving that it was most successful as the center of the Aesthetic Movement. This study examines the gallery's association with the Aesthetic Movement; it also goes much further, addressing how the institution's reputation was maintained after the waning of the Aesthetic Movement in 1882. The first chapter explores Lindsay's background, the formation of the gallery and its relationship to later exhibition trends, and the urban environment of New Bond Street. Chapter two covers the Aesthetic Movement in a multidisciplinary approach--the role of popular journals, and the relationship between literature and art which informed the connections made between the Grosvenor artists and the Aesthetic Movement as a whole. In chapters two through five an analysis of the artworks shown in augmented by memoirs of figures behind the scenes and by assessments of critical writings of the period in order to evaluate how the artists were viewed at the time. Lindsay challenged the normative role of exhibition halls

by promoting the works of experimental artists who themselves were dissatisfied with traditional arenas. The dissertation presents a contextual reading of the Grosvenor which reconstructs the situation that gave rise to Lindsay's advanced staging of avant-garde art within a new exhibition system. [Author Abstract]

19.) **Deusner, M. B.**
A network of associations: Aesthetic painting and its patrons, 1870--1914.
Ph.D. dissertation, University of Delaware.
2010.

This study reframes transatlantic Aesthetic painting as a visual language of interconnection and systematic organization, with an emphasis on its development and dissemination through patronage networks in England and America. It foregrounds the paintings of James McNeill Whistler, Edward Burne-Jones, Lawrence Alma-Tadema, Thomas Wilmer Dewing, and Dwight Tryon, among others, as actively meaningful and mobile objects thoroughly engaged with the "networked" mentality of their historical moment. Although Aesthetic paintings are often regarded as having had a primarily negative value, serving an escapist function by isolating and insulating their owners from the pressures of the modern industrial world, they were often favored by the very politicians, financiers, and corporate leaders who shaped that world.

Through a series of case studies, I offer a new account of the movement's transatlantic evolution and significance, arguing that in form and in function, Aesthetic paintings articulated, rather than evaded, the essentially incorporated and networked character of the commercial and political arenas in which turn-of-the-century patrons were so intimately involved. I have chosen as my organizing theme the concept of the network, which experienced a remarkable transformation from mid-century, when it was primarily attached to concrete systems (railroad tracks, telegraph wires), to the 1890s, when it was extended to include invisible forces and sensations (such as a network of political machinations). This shift signals the emergence of a new type of integrative conceptual thinking that considered diverse individuals and things to be connected through overt and covert lines of influence and communication--an idea exemplified by the incorporated and vertically integrated business, the behind-the-scenes political maneuverings of the club world, and

even the popular spiritualist séance. In the midst of this networked moment emerged the Aesthetic Movement in interior decoration, whose advocates insisted that all aspects of a decorated room must be brought into a harmonious relationship, and that even the curve of a table leg might exert a moral and psychological influence on that room's inhabitants. The pictorial arts played an active role in such interiors, and my analysis of Aesthetic paintings is the first to situate them within this networked decorative, social, and psychological context. The overarching goal of "A Network of Associations" is to make British and American Aesthetic paintings legible to contemporary scholarship in new ways, primarily by recuperating the integrative priorities shared by many of their turn-of-the-century makers, owners, and viewers. Following an introductory essay that outlines the systematic aspects of Aestheticism through a reconsideration of Whistler's Peacock Room, three case studies explore how Aesthetic networks operated in

political, philanthropic, and corporate spheres--from the impact of Burne-Jones's Perseus series upon the constitution of Tory politician Arthur James Balfour's interpersonal relationships and public reputation, to the surprising points of intersection between Dewing's garlanded women and the Detroit railroad car building combines managed by Charles Lang Freer. Poised between these transatlantic poles, a central chapter on the New York mansion and art collections of Henry Gurdon Marquand captures the changing meanings attached to Aesthetic pictures and furnishings as they were transported from England to America and installed within a decorative interior whose points of reference were at once local, national, and global. [Author Abstract]

20.) **Deutsch, A.**
George Christian Gebelein: The craft and business of a modern Paul Revere.
M.A. thesis, University of Delaware. 1995.

This study re-examines the craft and business practices of George Christian Gebelein (1878-1945), the Boston silversmith. As a young man, Gebelein trained under elder silversmiths who instilled the value of fine, handcrafted silver in their apprentice. Working during the early twentieth century, Gebelein participated in the arts and crafts movement, a powerful aesthetic movement that advocated a return to handcraftsmanship. In 1909, Gebelein opened his own shop and began developing a "business-like method" that allowed him to create the handcrafted silver he valued while still maintaining a profitable business. By incorporating antiques and silver produced by other silver companies into his inventory and selectively employing industrial production techniques, Gebelein was able to run a money-making business for over thirty years. His

mystique as a craftsman, expert, and scholar of silver and metal objects drew customers, collectors, craftsmen, and curators to his shop and won him the title, "the modern Paul Revere." [Author Abstract]

21.) **Dickie, C.**
Representing dance: Early modern dance and modernist women's writing, 1880--1940.
Ph.D. dissertation, Queen's University (Canada). 2005.

This dissertation argues that images of non-balletic female dance in representative examples of modernist women's writing suggest resistance to modernism's impersonality aesthetics. I find further evidence for Suzanne Clark's theory of a "feminist countermovement" to masculinist definitions of modern art as anti-sentimental, impersonal and autonomous by situating images of female dance in late nineteenth and early twentieth-century literature in the context of early modern dance, an aesthetic movement pioneered by women who valued self-expression as a revolutionary aesthetic principle. Existing scholarship on dance and literary modernism tends to view early modern dance as a parallel movement to French Symbolisme, whose emphasis on fluidity and suggestiveness modern dance certainly shares. In truth, however,

modern dancers distanced themselves from Symbolisme's "art for art's sake" aesthetic by assuming choreographic responsibilities to facilitate women's self-expression, and by theorising dance in writings that combine manifesto with autobiography. The lack of critical attention given to performed and written texts associated with early modern dance masks the important fact that such influential dancers as Loïe Fuller, Isadora Duncan and Ruth St. Denis were very articulate about their feminist and aesthetic goals. These dancers describe organic, emotional and so-called "natural" movement as a central exploratory field in their choreography, through which they hoped to discredit ballet's artificial constructions of femininity as passive and non-creative. Accordingly, I suggest that scholarship has erroneously relied on images of the impersonal and "illiterate" dancer in the Symboliste-inspired writings of Stéphane Mallarmé, Paul Valéry, W. B. Yeats and Edward Gordon Craig to explain the literary significance of a dance movement that in fact had more in

common with the feminist goals of such women writers as Virginia Woolf, Gertrude Stein and Mina Loy. I provide evidence for modern dance's rejection of ballet technique paralleling the efforts of some women writers to break from what they saw as masculimst literary traditions. In particular, I point to the frequency by which women writers invoke the dancer's concept of a "living body" as a subversive materialisation of women's feelings and beliefs to protest the repression of female difference in such aesthetic movements as Italian Futurism and French Symbolisme. [Author Abstract]

22.) Fischer, C. K.
Thomas Jeckyll, James McNeill Whistler, and the "Harmony in Blue and Gold: The Peacock Room": A re-examination.
Ph.D. dissertation, Virginia Commonwealth University. 2013.

This dissertation uncovers three previously unrecognized innovations of Thomas Jeckyll in the Peacock Room. At the same time, the dissertation admits that sometimes James McNeill Whistler chose a more conventional path in the design of the room than previously acknowledged. The dissertation illuminates the often overlooked principle of Classical Decor, first described in the first century BC by Vitruvius, and analyzes how it was instituted in the Peacock Room. Four major points illustrate this conclusion. First, the meaning of the sunflower in the West is explored to account for the flower's popularity and absorption into ancient heliotropic lore. Thomas Moore's poetry may have inspired Aesthetic Movement designers such as Jeckyll to use the motif.

Second, this dissertation demonstrates that the Peacock Room is only a distant descendant of the traditional European porcelain chamber. It was a new idea to turn the porcelain chamber into a dining room. Further, the room lacks two of the three key features of a porcelain room: lacquer panels and large plate-glass mirrors. When Whistler made the surfaces of this room dark and glossy, he made the room more traditional, aligning it with the customary lacquer paneling of porcelain rooms. And Jeckyll's shodana shelving system in the Leyland dining room was without precedent in porcelain or other kinds of Western rooms, with influences from Japan and China. Third, Decor in the dining room was revealed as an established pattern in eating rooms from Ancient Roman triclinia to the present day. Fourth, Decor is present in the Peacock Room in four ways: in the trappings of the table used to decorate a dining room, in the darkness of this dining room, in the use of a foodstuff, the peacock, to decorate the room, and in the hearth's sunflowers. Through the lens

of the history of Western domestic interiors, significant innovations by Jeckyll have been brought to light, and the meaning of specific elements in the Peacock Room has been elucidated. Jeckyll and Whistler gave the world a sensational story in the Peacock Room but also a complex work of art that is only beginning to be illuminated. [Author Abstract]

23.) **Friedman, D. E.**
Erotic Negativity and Victorian Aestheticism, 1864--1896.
Ph.D. dissertation, University of California - Los Angeles. 2012.

What is the relationship between erotic desire and aesthetic contemplation? This question was central to three of British aestheticism's most notable theorist-practitioners: Walter Pater, Oscar Wilde, and Vernon Lee (Violet Paget). "Erotic Negativity" contends that Pater, Wilde, and Lee exercised Hegel's concept of "the negative" to describe the relationship between aesthetic experience and erotic response. The aesthete, when he or she gazes upon homoerotic aesthetic representation, undergoes a shock that is at once both intellectual and visceral: this is the revelation of an erotic desire, previously hidden as a determinate absence in the mind, which shatters and radically reconfigures the structure of consciousness itself. This process, which Hegel terms the "encounter with the negative," elicits not only greater self-

knowledge, but also critical insight into the cultural and historical significance of the aesthetic object. "Erotic Negativity" thus demonstrates that the most profound critiques of modernity must ground themselves in the reflective freedom that is created by artistically mediated experiences of erotic desire. Chapter one discusses Walter Pater's early essays, up to and including Studies in the History of the Renaissance, as the Aesthetic Movement's most elaborate and influential explication of negative homoeroticism. Chapter two examines Pater's post-Renaissance writings, such as "A Study of Dionysus," Marius the Epicurean, and Plato and Platonism. In these works, Pater turned to early anthropology to show how erotic violence, rather than undermining the humanist subject, actually enables the creation of that subject through an aesthetically mediated homoerotic encounter with the negative. Chapter three discusses Oscar Wilde's novella "The Portrait of Mr. W.H.," which advances a homoerotic reading of Shakespeare's sonnets to express the insight he gains from the

theory of erotic negativity: namely, that language's limited ability to capture the "truth" of erotic desire need not undermine the fundamental perdurability of individual subjectivity. Finally, chapter four shows how Vernon Lee's essay "Faustus and Helena: Notes on the Supernatural in Art" and her fantastic tales "Oke of Okehurst" and "Prince Alberic and the Snake Lady" create a feminist revision of masculine homoerotic negativity by presenting women's supernatural encounters with history as erotically charged experiences that create new forms of feminine sexual subjectivity. [Author Abstract]

24.) **Gaggin, J. R.**
Hemingway and Aestheticism (Decadence).
Ph.D. dissertation, University of Pennsylvania.
1986.

Artists of the nineteenth-century aesthetic movement valued a detached perspective; Hemingway's writing often portrays highly engaged characters. Despite this seeming disparity, Hemingway's work has close affinities with that of the earlier artists. When viewed from a broad perspective as a current of thought running throughout the Victorian period rather than as a brief, quirky trend toward decadence at the end of the century, aestheticism informs and illuminates Hemingway's themes. This dissertation first examines concerns of the aesthetes as revealed in works by Tennyson, Browning, the Pre-Raphaelites, Pater, Huysmans, and Wilde and then discusses how Hemingway might have absorbed such ideas through extensive reading and through his associates during the early years in Paris. Subsequent chapters relate themes of Hemingway's writing

to those of aestheticism and the specific movements that grew out of it: art for art's sake and decadence. The concluding section suggests that such connections have implications for the larger concerns of modernism. Many characters in Hemingway's fiction are aesthetic observers who like their nineteenth-century forebears consider themselves to be singularly percipient people. They share with the aesthetes a respect for momentary impressions, acute observation, detached contemplation, and the creativity that sometimes results from this detachment. Right vision takes on ethical and moral values. The art-for-art's-sake movement expanded these notions by disconnecting creativity from received cultural values and by substituting an attention to style and craft. This emphasis translates into Hemingway's themes of professionalism, connoisseurship, and purity of style. He rejects as faking, however, the art-for-art's-sake advocacy of artificiality. Hemingway shows similar ambivalence toward the issues of decadence, which are treated throughout the

fiction. The characters' isolation in a declining world resembles that of the decadents. An aesthetic perspective compensates both sets of figures for the desiccation of their culture. When decadence leads to excess or affectation, however, it can be the subject of scorn. Hemingway's consistent interest in homosexuality, androgyny, and the implications of gender can be better understood by examining the decadents' treatment of these issues. [Author Abstract]

25.) **Gourianova, N.**
The early Russian avant-garde, 1908--1918: The aesthetics of anarchy.
Ph.D. dissertation, Columbia University. 2001.

This thesis focuses on the general theoretical issues and poetics of the early period of the Russian avant-garde and offers a revision of the traditional historical perspective. Although many historical and critical works treat the later stage of the Russian avant-garde, the early period is still not analyzed with the same attention. I establish this early period as a separate stage characterized by its own features and its own aesthetics, which I define as an aesthetic of anarchy. It is based on a new interpretation of art and human creativity. This aesthetic, which underlies all the formal innovations of the early Russian avant-garde, is manifested in the non-uniformity of the avant-garde itself, in its diversity, as well in its interest in fields and genres which seem to erode the traditional boundaries of art. The anti-canonical formal innovations of this period were not produced for

their shock-value so much as from a necessity to erode the contrived borders between the "high" and "low", and to deconstruct the old aesthetic system. As a result, the early Russian avant-garde recognized many different coexisting aesthetic systems developing simultaneously. I argue that political anarchism has little in common with the idea of ontological anarchy, which denies any absolute structure. It is inspired not by a social utopia, which inevitably calls for temporal, epochal "closure" but rather by another by-product of philosophical anarchism, distopia with its paradoxical mixture of nihilism and "openness." Nevertheless, in 1917-18 many avant-gardists showed obvious sympathy toward anarchism, and they regularly published articles on art and literature in the anti-Bolshevik Anarkhiia, the weekly paper of the Moscow Federation of Anarchist Groups. This assignment of interest was short-lived and contribute to the demise of the aesthetic of the early period of the avant-garde. At the moment when an aesthetic movement becomes a matter

of practical politics it has reached its terminal phase. In my manuscript I analyze works by a wide range of artists and poets: Kandinsky, Larionov, Goncharova, Guro, Filonov, Malevich, Khlebnikov, Maiakovsky, David Burliuk, Kruchenykh, and others. My topic involves such disciplines as visual art, literature, cultural theory and philosophy. [Author Abstract]

26.) **Gregorich, C. L.**
H. Siddons Mowbray: "The Crystal Gazers".
M.A. thesis, Michigan State University. 1991.

This thesis deals with the iconography of H. Siddons Mowbray's painting, Crystal Gazers. Mowbray's biographical data is given within the milieu of the American art scene of the late nineteenth century. The Pre-Raphaelite movement is also discussed in relation to Mowbray as he executed paintings with carefully articulated physical detail and he was also, due to the Pre-Raphaelite painters influence, interested in Italian Trecento art. The American Aesthetic movement, a direct result of Pre-Raphaelitism's emphasis on decorative surface, is examined as Mowbray was a key figure in promoting Aestheticism in his early-to-mid career. Mowbray's involvement in the American Renaissance is also discussed. The major findings of this study are the connections between Pre-Raphaelitism, Rosicrucianism, Symbolism, American Aestheticism, and the

American Renaissance. Avant-garde art movements in Europe influenced expatriated American artists, like H. Siddons Mowbray, who brought these styles back to the United States and changed American art. [Author Abstract]

27.) **Grimstad, K. J.**
*Ancient heresy in modern literature:
Gnosticism, aestheticism, and Thomas Mann's
"Doctor Faustus".*
Ph.D. dissertation, The Union Institute. 1997.

Using a cross-disciplinary approach, this study explores a gnostic subtext in Thomas Mann's Doctor Faustus, framed within a consideration of European aestheticism as a form of modern gnosticism. The extremist, dualistic, and world-rejecting--though also transcendent and subversive--gnostic sensibility found expression in the heretical sects that flourished during the early Christian era and in the pessimistic religious and cultural imagination of the late modern age. Thomas Mann's use of a gnostic cosmogonic myth in the prelude to the Joseph tetralogy is placed in the context of the rediscovery, publication, and translation of original gnostic writings in the late nineteenth century, followed by vigorous scholarly and popular interest that converged in the Weimar era. In the movement called aestheticism,

described in the coinage of the day as the religion of art, the ancient gnostic hatred of the world and longing to escape into other-worldly redemption recrystallized in modern guise. The texts of decadent aestheticism stand as both a culmination and repudiation of modernity itself as a ruined work, counterbalanced by the emergence of the l'art pour l'art ideal of an autonomous sphere of escape and refuge from the perceived horror. This purer realm of absolute art represented an other-worldly sacred reality that culminated in modernist abstraction. These two features--extreme negativization of the world intertwined with affirmation of uttermost estrangement from the world--constitute the gnostic schema encoded in European aestheticism. This study encompasses the period spanning the emergence of the aesthetic movement in the nineteenth century through the end of the Weimar Republic. As depicted in Mann's Faust novel, during these decades the world-rejecting aesthetic ideology of the cold, remote, demonically inspired modern

artist Adrian Leverkuhn converged with the life-destroying political ideology of the Nazi regime, which offered the total state as the total work of art. By examining the gnostic schema of aestheticism through the prism of Leverkuhn, this study addresses the ambivalent implications of an aesthetic ideology that emerged in the context of growing scholarly and popular interest in ancient gnostic religion during the generations preceding the political catastrophes of the twentieth century. [Author Abstract]

28.) **Hayes, A. L.**
Kitten has claws: The feminine, the feline, and the threat of the New Woman in Cecilia Beaux's "Sita and Sarita".
M.A. thesis, The University of Alabama - Birmingham. 2013.

This thesis examines Cecilia Beaux's painting Sita and Sarita (1893-1894) as it expresses the conflicts of the women's rights movement, changing gender roles, and shifts in the perception of female sexuality and intellectualism in the late nineteenth century. The argument hinges on the quality of the woman's gaze and the anthropomorphic nature of the cat, which encompass growing interests in and fears of female mental capacity, sexuality, and animality. Examining how the portrait functions within three major traditions-- depictions of young women in white dresses; women lost in thought or in reverie; and portraits of people with their pets, specifically women with cats--helps to illuminate the significance of the sitter's gaze and the cat.

Locating the painting within the legacy of the Aesthetic movement's "white paintings" serves to illustrate how Sita and Sarita borrows this visual language. A brief history of the development of pet-keeping practices illustrates how pets took on new roles within the domestic realm. Discussion of Edouard Manet's Olympia as a source for the cat in Sita and Sarita identifies concerns about sexual self-possession. Referencing nineteenth-century Egyptomania, the thesis argues that the black cat alludes to Cleopatra as a figure of sex, power, and female ambition, and to the goddess Bastet, a mother and protector, thus creating a tension between the female and the feline as threatening seductress and natural caretaker. Examining popular literature of the nineteenth century, namely Charlotte Perkins Gilman's "The Yellow Wall-Paper," Lewis Carroll's "Alice in Wonderland" series, and Edgar Allan Poe's "The Black Cat" illuminates the implications of the sitter's reverie and the symbolic power of the cat. Beaux's life and writings support this new

interpretation of Sita and Sarita, as she was an independent, unmarried career-person who broke many boundaries as a woman while maintaining the view from an early age that women and men were ultimately equal. [Author Abstract]

29.) Heath, L. M.
John Ruskin and Greek art.
Ph.D. dissertation, University of Miami. 1995.

John Ruskin, the most influential figure in Victorian art criticism, was very much a part of the movement of nineteeth-century Greek Revivalism. He saw Greek art and myth from the vantage points of his romantic aesthetic, his political beliefs, and his personal spiritual struggles. Greek architecture was largely dealt with in terms of the Greek Revival 'abuses' that Ruskin so deplored, such as the use of machines made ornaments. Ruskin's loss of faith in Christianity and an afterlife in 1858 significantly altered his subsequent attitudes towards Greek art and myth. After 1858 he found new strengths in Greek art, interpreting them as symbolic of the moral validity of ancient Greek religious beliefs. In later works he broadened the definition of Greek art to include any art in which "the thing represented means more than itself" (24:280-1). At this point, he was no longer

dealing with the subject of "Greek art" as it would be commonly understood. Ruskin's "Greek artist" is not a historical figure, but a mythological one, evaluating in order to support his visions for what nineteenth-century England ought to be. Ruskin was always hostile to the imitation of specific Greek forms in nineteenth-century architecture, sculpture and painting. He viewed the physical elements of Greek style as alien to English culture, although the conclusions that he drew from its alienness changed dramatically as his aesthetic matured. In early works he presented the "unnaturalness" of Greek architecture and art as proof of its inferiority. But after 1858 he treated its strangeness as evidence of its nobility. Ruskin wanted the English artist to internalize the best of both Greek and Gothic styles--to combine the Greek understanding of light and shade, its "dignity," veracity, and intense study of the body, with the Gothic color-sense, its devotion, and its mastery of the portrayal of the face and head. By the 1880s and 90s, "Hellenism" was exchanging its

Victorian face for something quite different, something which Ruskin was losing the power either to thwart or to approve. For a variety of reasons, the influence of Ruskin's opinions about the Greeks was minor, although he did have an impact on leaders of the Aesthetic movement like Walter Pater and Oscar Wilde. Many of his general ideas suggest directions in which Modernism is going to move--even if he himself would not have been comfortable with how his ideas would be developed. [Author Abstract]

30.) **Jespersen, J. K.**
Owen Jones's "The Grammar of Ornament" of 1856: Field theory in Victorian design at the mid-century (Britain).
Ph.D. dissertation, Brown University. 1984.

Owen Jones's The Grammar of Ornament of 1856 is the most important visual history of ornament in the bibliography of nineteenth century design. The Grammar is an original work of collaborative scholarship and art. In aim universal and comprehensive, the Grammar is comparative and critical in the almost 2400 examples of ornament illustrated with 100 chromolithographic plates and engravings. Building upon progressive ideas of flat pattern conventionalization which were, in Britain, especially marked in the Gothic Revival circle of designers epitomized in the ornament of A. W. N. Pugin, the Grammar extends and alters these ideas with its emphasis on field design. This stems from Owen Jones's profound knowledge of and enthusiasm for Moorish ornament. The main thrust of the liberal reform in art and design

centered on the attention to flat polychromed surfaces given to geometrically evolved patterns which emphasize a new interpretation of the original historical model while looking to nature to provide the ultimate sources of inspiration for new forms of ornament. In its valuation of the aesthetic of repose, the Grammar synthesized Victorian advances in the sciences of psychology and physiology to embrace a new visual aesthetic based upon sensation and abstraction. The Grammar is a major contribution to those progressive ideas in Victorian culture which it also exemplifies. Its ideas had a major influence on the Aesthetic Movement and Art Nouveau. It conditioned attitudes toward design which continue to be influential down to the present day. [Author Abstract]

31.) **Jung, J. A.**
The Diva at the fin-de-siecle.
Ph.D. dissertation, University of California - Los Angeles. 1999.

This project examines the emergence of a cultural archetype I refer to as the "Diva," an actress or opera singer who uses her mastery of art and aesthetic style as a means to real power. Particular issues include the relationship between the Diva and her male admirers and impersonators, the political implications of reading the Diva as a powerful woman rather than a dismissive stereotype, and the insights to be gained into the works of various nineteenth-century authors once the importance of this archetype is recognized. Though women performed in the theater and opera house long before the nineteenth century, this project shows why the Diva rose to special prominence in the 1890's, noting the influence of changes in drama and opera, the New Woman, and the Aesthetic Movement. The final decades of the nineteenth

century witnessed an explosion in the number of texts about Divas, investing them with progressively more respect and credibility. Similarities among these many texts suggest a standard Diva plot, which reveals the sources and uses of her power. Chapter 1 reviews existing criticism of the Diva archetype and situates the study within a number of debates, including the function of drag (as Diva worship), the possibility of deriving power from marginality, and current methodologies of reading male-authored women characters. Chapter 2 traces the emergence of a standard Diva plot throughout nineteenth-century works by Thackeray, Reade, Collins, Bulwer-Lytton, Eliot, and Meredith, outlining cultural attitudes toward the figure. The gradual ascendancy of the Diva as a figure worthy of respect is the subject of Chapter 3, which looks at texts by du Maurier, Moore, and Shaw. The issue of the Diva's relationship to her male spectator comes to the

fore in Chapters 4 and 5, which focus respectively on the Diva's function in the work of Henry James and Oscar Wilde. These chapters also consider the factor of James' and Wilde's non-heterosexuality, suggesting continuities between the Diva's affect in the 1890's, and the prominent cult of the Diva so widespread in contemporary, gay popular culture. [Author Abstract]

32.) **Katsan, G. M.**
Unmaking history: Postmodernist technique and national identity in the contemporary Greek novel.
Ph.D. dissertation, The Ohio State University. 2003.

As an aesthetic movement, postmodernism is selectively adopted and adapted by writers outside the mainstream of the West. This study investigates the ways that Greek authors have incorporated postmodernist literary techniques after the fall of the Junta in 1974, particularly within the mode of historiographic metafiction. Postmodernism is seen as a global phenomenon, and the implications of the mixing of "globalized" postmodernist culture with local cultures are considered. The mode of historiographic metafiction supplies a framework for an investigation of larger postmodernist concerns such as the crisis of representation, the unreliability of language, the undecidability of meaning, and the fragmentary nature of

knowledge that is unavoidably mediated by narrative constructions. In the case of Greece, due to the prevalence of the nationalist modernism of the Generation of the Thirties, postmodernists have maintained a fascination with the notion of national identity. These authors have used postmodernist techniques to critique the modernist ideology of national identity while reflecting upon more general postmodernist aesthetic, socio-economic and historical issues. Because of the persistence of national identity in these writings, postmodernist texts in Greece can be seen as "national allegories." The use of historiographic metafiction by authors such as Ares Alexandrou, Rhea Galanaki and Vassilis Gouroyiannis shows a clear departure from the notions of Greek national identity formulated by earlier writers and intellectuals and streamlined by official institutions, towards conceptions of identity as decentered, multivocal and inclusive. The

comparison of these authors to writers from other national traditions such as Salman Rushdie, Manuel Puig, Angela Carter and Orhan Pamuk, broadens conceptions of historiographic metafiction and explores the themes of ideology and national identity in conjunction with the problematics of history. [Author Abstract]

33.) **Kent-Drury, R. M.**
Authority and landscape in Alexander Pope's "Eloisa to Abelard".
M.A. thesis, California State University - Long Beach. 1993.

Alexander Pope's Eloisa to Abelard is best understood through a close analysis of its landscape elements. Although scholars of landscape history occasionally draw on isolated elements from the poem to underscore some point pertaining to a broad aesthetic movement, no thorough analysis has been performed. This analysis is important because it shows that the poem was written in response to a number of Pope's personal and political concerns and sheds light on Pope's psychological and creative process as a poet. Moreover, analysis of the landscape elements demonstrates that Pope was thinking about the expressive possibilities of landscape twenty years earlier than the date presently suggested by landscape historians.
[Author Abstract]

34.) **Kim, H.**
Objects and knowledge: A historical perspective on American art museums.
Ph.D. dissertation, The Ohio State University. 1999.

The aim of the dissertation is to reinterpret the history of American Museums based on the research question of how the meanings of education in American museums have been constructed and have shifted within particular historical, social, economical, and cultural contexts. In pursuit of this question, historical analysis dependent on recent developments of scholarship is used. By reconsidering events and conditions that preceded those of today, this study is intended not only to illuminate similarities but also to examine how different some contexts and circumstances may be. This study also attempts to situate the examples of particular museums in the larger contexts from which they arose and within which formative events took place. First, the genesis of the idea of the American museum within its historical

context is examined. In investigating the origin of the American museums, the concept of the museum is traced from the ancient time to the twentieth century. Second, the Museum of Modern Art (MoMA) in New York City is discussed as an example the museum during the period of economic depression in the 1930s. The aesthetic movement of modernism, New Deal Relief programs, and progressive educational movement during the 1930s contributed in the construction of the meanings of education at the MoMA. Third, as an example representing the museum movement during the 1970s, the Hirshhorn Museum and Sculpture Garden (HMSG) is described. With the shift of social context of the late 1960s, new government funding in support of the arts (NEH and NEA) and the postmodern movement in the fields of aesthetics and education shaped the meaning of education at the HMSG. Finally, this study concludes that the identity of American museums did not emerge suddenly, but had a long and complex history, which shapes what

American museums are today. Additionally, the detailed events and shifts described in this study suggest that the meanings of the American museums were constructed with reference to social changes, economic needs, aesthetic theories and general educational reform movements. [Author Abstract]

35.) **Krumrey, A.**
The notion of aestheticism in the works of Oscar Wilde and Hugo von Hofmannsthal with special reference to Salome and Elektra.
Ph.D. dissertation, University of London, School of Advanced Study (United Kingdom). 2004.

This thesis is concerned with the literary phenomenon of aestheticism and its specific implications for the work of Oscar Wilde and Hugo von Hofmannsthal. The purpose of this comparative study is to reveal and analyse patterns of divergence and conformity as between Wilde's and Hofmannsthal's notion of aestheticism by examining Salome and Elektra as dramatic representations reflecting their respective theoretical understanding of aestheticism. Each play is examined within the context of their writings and, by extension, of the Aesthetic Movement in Europe. The introduction provides a brief survey focusing on the development of aestheticism as a European phenomenon and especially on its critical

assessment by recent scholarship in order to establish a literary-historical context for the exploration of the notion of aestheticism in the work of Wilde and Hofmannsthal. The aim of chapter 1 is to establish existing affinities and contrasts in the distinctive idea of aestheticism as embodied in the oeuvre of the two writers rather than to pursue a separate aestheticist discourse for each author. As the literary relations between Wilde and Hofmannsthal are of far greater importance than is generally acknowledged, their respective notions of aestheticism not only need to be explored and compared in detail but the impact of Wilde's work on Hofmannsthal also requires to be examined within the context of aestheticism. Furthermore, the thesis shows in what ways Hofmannsthal's aestheticist ideas underwent change during his lifetime and especially why it was that he distanced himself from his original understanding of the concept after the turn of the century. Chapters II and III juxtapose two

independent critical interpretations of Salome and Elektra, while chapter IV offers a comparative analysis of the two aestheticist concepts translated into the medium of theatre in order to reveal the complex interrelations of both works. To bring the comparison to its conclusion, Wilde's and Hofmannsthal's differing modes of aestheticism, as manifested in Salome and Elektra, are contrasted within their literary context. [Author Abstract]

36.) **LaVigne, M.**
Rhetorical moves: Pursuing the Potential for Movement in the Arts of Rhetoric and Dance.
Ph.D. dissertation, The University of Wisconsin - Madison. 2010.

This project investigates the persisting problem of rhetorical immobility, which is marked by uncompromising ideologies, recalcitrant institutions, and a deficiency of reasonable words. It seeks the potential for rhetoric's capacity to move choices, subjects, and judgments amid this inflexible environment. To do so, the project turns toward dance as a concept and perspective of movement and finds that dance provides a language to (re)capture rhetoric as an art that moves. I begin with a simple question: What is the art of rhetoric? By holding open this question, the first chapter works from rhetoric's classical orientation as a techné to conclude that "the art" of rhetoric can be thought of as an aesthetic movement closely aligned with the concept of dance. This aesthetic

rendering of rhetoric as an art opens it as a practice that can invent opportunities for choice, foster different ways of standing, and enable activities of judgment. These rhetorical moves--invention, subjectivity, and judgment--are each explored in turn. Chapter Two considers the implications of the ancient Greek tragic choros to see how the work of invention moves and what it yields. In the dance of the tragic choros , its odes, I find that the movements of gathering, shifting, and turning open up the potential for alternatives to the linearity of civic discourse and mythologies. Chapter Three explores the German modern dance during the Weimar Republic because it speaks the travails and possibilities of modern subjectivity. By analyzing Kurt Jooss' 1932 dance The Green Table, I examine how and why rhetoric depends on subjects that can stand in and move between different places--particularly when different forms of institutional authority hinder such movement. Chapter Four considers the state of judgment as a rhetorical

problem of movement. It looks to postmodern dance and choreographer Bill T. Jones in order to learn how abstractions of form and content can yield acts of questioning that open up the reflective reason and imaginative thinking required to foster judgments of making sense. In the end, this project strives to underscore our need for rhetorical movement and the enduring power of dance. [Author Abstract]

37.) **Leck, R. M.**
Georg Simmel and the soul of German culture, Geist-Politik: Fin-de-siecle to the Great War.
Ph.D. dissertation, University of California - Irvine. 1995.

The goal of this manuscript is to resurrect the cultural significance of Georg Simmel (1885-1918). Simmel is widely recognized as the founder of the discipline of sociology in Germany. For most of his academic life, however, he taught in the Philosophy Department of Berlin University. In addition to his sociological inclinations, he was one of Wilhelmine Germany's greatest exponents of Nietzschean philosophy. His combination of a Kantian and socialist sociology and Nietzschean existential philosophy is the basis of what this study refers to as Geist-Politik. The best example of this type of cultural critique was his Philosophy of Money (1900). This study contends that Simmel's cultural influence upon the left-wing intellectual avant-garde was unrivalled in the Wilhelmine period. The historiographical and

cultural reasons for his descent into relative obscurity after 1918 are explored. Simmel's cultural impact was greatest in three cultural spheres. First, Kurt Hiller drew upon Simmel's theory of culture in developing the aesthetic philosophy of early Expressionism. This study is the first to argue for Simmel's seminal contribution to what became the greatest aesthetic movement in twentieth-century German cultural history. Second, Simmel's philosophy was the basis for political activism against patriarchal and heterosexist visions of culture. Previous to the Great War, Hiller was one of the most vehement critics of laws against homosexuality. The intellectual foundation of his opposition was Simmel's philosophy of history. Another Simmel student, Helene Stocker, drew upon her mentor's theories of gender in founding the Mutterschutz movement which defended women's liberation and the rights of unwed mothers. Third, Simmel was the primary mentor of two of Germany's most renowned Communist intellectuals: Georg Lukacs and Ernst Bloch.

Simmel's contribution to their intellectual development as anti-capitalist thinkers has heretofore been grossly underappreciated. [Author Abstract]

38.) **L'Enfant, J. C.**
Truth in art: William Michael Rossetti and nineteenth-century realist criticism.
Ph.D. dissertation, University of Minnesota.
1996.

"Truth in Art: William Michael Rossetti and Nineteenth-Century Realist Criticism" examines the art criticism of an underrated member of the Pre-Raphaelite Brotherhood and places it within the context of Victorian culture. After an account of Rossetti's family background and education, Chapter One gives an overview of the nature and scope of Rossetti's periodical reviewing and the function of much reviewing in Victorian society. Chapter Two assesses William Rossetti's role in the Pre-Raphaelite movement, first as editor of the Germ, then as a beginning reviewer. His early realist creed, derived in part from John Ruskin's "truth to nature" but characterized from the beginning by an individual cast of thought, is seen in reviews of fellow Pre-Raphaelites Dante Gabriel Rossetti, John Everett Millais, and William Holman Hunt. His outlook broadens,

however, with frequent reviewing of a variety of works, and his point of view is examined in relation to Ruskin and other critics such as F. G. Stephens. Chapter Three discusses a crucial development in Rossetti's thought: a new appreciation for "style" born of exposure to French art. In the 1860s Rossetti's aesthetic ideas underwent further development with his enthusiasm for Japanese art, and Chapter Four examines how this tradition promoted Rossetti's sensitive response to James McNeill Whistler. This chapter also presents new findings on Rossetti's own collection of Japanese art. Chapter Six analyzes Rossetti's different reactions to the Classical Revival and Gothic Revival, both of which contributed to a new phase of Pre-Raphaelitism that could sometimes satisfy both Rossetti's aestheticism and his realism through its vital spirit of the past. Rossetti's final approach, best characterized by his own phrase "aesthetic realism," emerges between 1874 and 1878. Reviews of exhibitions at the Dudley and Grosvenor Galleries,

showcases for the Aesthetic Movement, place him squarely in the nineteenth-century realist tradition, but also show a twentieth-century determination to examine works closely as autonomous objects. The study concludes by defining Rossetti's "realism," comparing it to the positions of fellow critics, especially Sidney Colvin, and positing Rossetti's importance as an authoritative spokesman for humanistic values in Victorian culture. [Author Abstract]

39.) **Lindberg, A. L. C.**
Konstpedagogikens dilemma: Historical roots and contemporary strategies.
Fil.Dr. dissertation, Lunds Universitet (Sweden). 1989.

The starting point of this study is a complex of problems, roughly speaking the difference between idea (the aim of Swedish cultural policy being art for everyone) and reality (almost 70% of the population never attend art shows). This discrepancy is the chief raison d'etre of art education, here defined as a pedagogy concerned with our ability to perceive, understand and experience the work of art. Nevertheless, art education is not generally considered necessary, and when applied suffers from fundamental contradictions intrinsic to the visual arts field (Bourdieu). These contradictions appear as a wavering between the objectification and the subjectification of the viewer, materialized in, respectively, a lecturing attitude and a charismatic attitude, a state of things referred to as the dilemma of art education.

Based on Habermas' theory of the public, the first part of the thesis maps the modern origins of art education in Sweden. Making specialists out of artists and critics and disqualifying a major part of the public, the growth of the visual arts institution also makes way for art education. In part II art education is shown to enter into alliances with critics as well as advocates of modernity in the England of the Aesthetic Movement and the Germany of the Reform Movement, an issue repercussing with Swedish art educators at the end of the century. The breakthrough of 20th century modernism radically changes the conditions of art education. Obviously, the charismatic attitude has profited from modernism, as well as from the accelerated "cultural release from tradition" (Ziehe) of recent years. The problem of art education in late modern society is discussed in an analysis of four examples of practice. Drawing on Bernstein's concept of integrated code, the thesis classifies these as "alternative education", the common central characteristic being the emphasis on

what is here termed the common image, and lays down that the object of art education, rather than art itself, is a particular receiver's or a group's view of art phenomena. [Author Abstract]

40.) **Losa, M. L.**
From realist novel to working-class romance: An introduction to the study of the Brazilian, Italian, and Portuguese new social realist novel, 1930-1955, in light of new critical theory on realism, fiction, and reader response.
Ph.D. dissertation, New York University. 1988.

The novels discussed belong to an aesthetic movement which emerged in the Thirties and was practically extinct by the mid-Fifties. This movement professed the need for realism in art, defended the commitment to social issues, but received different names in different countries. Italy and Portugal both adopted the designation of Neo-Realism. Brazil, however, preferred a regionalist characterization: the Northeastern movement. In the United States the Naturalist label was extended to cover several authors of this period, although the narrower designation of proletarian novel was also used. The major scope of this study is to prove how this self-styled new social realist novel can be best

characterized by a number of romantic elements, especially when its protagonists are workers or peasants. Recent critical theory on the novel is discussed in the first part so as help establish the aspects in which the new social realist novel dissociates itself from the realist canon. The hero's conversion to a new faith and his choice of a perilous road to salvation are structural elements of the plot. Idyllic and melodramatic modes emerge as components of both fictive action and narrative strategy. Finally, the defense of selfless bravery on behalf of the community is introduced as part of a new morality of social solidarity. The open ending of this kind of novel suggests that if the reader is persuaded of the goodness of the hero's cause, he will feel like carrying on the unconcluded struggle himself. A major concern of new social realist novelists appears to have been that of generating upon their readers an effect of commitment towards social change. This study

contends that the new social realist novel deserves to be evaluated according to its own romantic, pragmatic programme, rather than to whether or not it succeeded in entering the ranks of the so-called great realist tradition. [Author Abstract]

41.) **Mackie, G. P.**
Oscar Wilde and the moral imagination.
Ph.D. dissertation, University of Toronto (Canada). 2006.

The complex relationship between Oscar Wilde's celebrity and his critical reception has, for the past century, been distinctly marked by a moral dimension. The publication history of Wilde's writings, from his earliest volume Poems (1881) to the posthumous De Profundis (1905) registers the impact of a series of morally-inflected Wilde myths on his position in the literary marketplace. "Oscar Wilde and the Moral Imagination" traces the development of Wilde's contested literary reputation from its origins in the popular culture of the aesthetic movement to his relegation to the margins of literary culture in the climate of moral hysteria that followed his imprisonment for homosexual acts in 1895. Emphasizing textual and material features in the publication history of Wilde's writings, I argue that the multiple and frequently contradictory ethical critiques that attended Wilde's aesthetic theories

were subject to the demands of different markets and publishing formats, and were designed to appeal to a variety of audiences as he actively cultivated a reception in moral terms. With the novel The Picture of Dorian Gray (1890-91) and the play Salome (1894), for instance, texts that thematize their own decadence, Wilde wrote with a shrewd awareness of his audience's moral expectations. As an ethical polemicist and celebrity artist, Oscar Wilde's engagement with his audiences was, to use two of his own terms, neither pure nor simple, as he negotiated his way through a culture industry whose commercialism he criticized, despite being profoundly implicated in it. [Author Abstract]

42.) **Mahoney, K. M.**
Appreciation and innovation: History and economics in late-Victorian aestheticism.
Ph.D. dissertation, University of Notre Dame. 2004.

Late-Victorian aestheticist historical literature wages a battle on two fronts against the twin consequences of modern consumerism, the degeneration of art and the erasure of the past. In their historical texts, members of the Aesthetic Movement model practices of literary production and aesthetic consumption designed to preserve the sanctity and the liberatory potential of a quickly eroding past and an embattled aesthetic realm. While the aesthetes understand the late-Victorian period to be a moment of crisis for the arts, their acute awareness of the realities of modernity inspires them to forge pragmatic compromises with the pervasiveness of market forces in their response to this crisis. Late-Victorian aestheticist authors endeavor to theorize a method of operating within consumer culture while at the same time

refusing the elision of history and ethics and the degeneration of the aesthetic they associate with that culture. This study traces a narrative of movement towards the center as members of the Aesthetic Movement come to believe that a liberatory aesthetic practice must emanate from the center of the culture it seeks to save. I begin with a reading of Swinburne's highly oppositional Sapphic sadistic poetic practices and argue that later aesthetes preserve his concern with history and economics while responding to the aesthetic crisis he identified in a less reactionary manner. I move on to consider Paterian spectatorship of history and Vernon Lee's theory of historicized consumption as exemplary models of ethical maneuvering within a culture of consumption. I conclude by discussing Baron Corvo's optimistic assessment of the relationship between art and consumerism, an assessment that is influentially rejected by his modernist successors. The reception of Corvo's works in the early-twentieth century serves as an indicative case study in the misapprehension of aestheticist literary

strategies, the primary problem that this study seeks to address. By clearing the aesthete's pragmatic compromises with consumer culture of the charge of passivity or naiveté, this project reconsiders the validity and effectiveness of the Aesthetic Movement's interactions with market society. [Author Abstract]

43.) **Masaki, T.**
A history of the toy book: the aesthetic, creative, and technological aspects of Victorian popular picture books through the publications of the firm of Routledge 1852-1893.
Ph.D. dissertation, University of Surrey (United Kingdom). 2000.

The aim of this study is to survey the toy book, the popular form of Victorian picture books, which was published in the second half of the nineteenth century in Britain on a huge scale by many publishers. Despite the formidable contribution to the history of picture books, the toy book has been completely neglected by English and American critics. This is the first serious survey of the Victorian toy book: the emergence and evolution of toy books and their link with the modern picture books. I concentrate on the toy book publication particularly by the firm of Routledge, because Routledge was the only firm that published toy books serially throughout the whole of the

second half of the nineteenth century and produced the masterpieces of Walter Crane and Randolph Caldecott in collaboration with the engraver-printer, Edmund Evans; in combination these three men significantly influenced later picture books. The thesis consists of three volumes: Volume I forms the text which discusses the historical evolution of and a diversity of images from toy books through the survey of design and technological development in the second half of the nineteenth century. In Chapter 1, I survey the publication history of toy books by the firm of Routledge. In Chapter 2, I discuss the design history of the front cover in relation to the aesthetic movement, the cultural attitudes of the time and printing history. In Chapter 3, I survey Victorian printers who were the most influential factor in toy book production. In Chapter 4, I fully discuss the development of the toy book into the modern picture book through the work of Edmund Evans.

Volume II consists of nine hundred illustrations which provides readers with a visual reference of both the developing history and the diverse design of toy books. Volume III is the bibliography/catalogue which includes details of each toy book and composite volumes. [Author Abstract]

44.) **Maybee Reagan, L. M.**
Literature, drama and film about the Vietnam War: Postmodern and postcolonial perspectives.
Ph.D. dissertation, Auburn University. 2003.

Literary texts about the Vietnam War, authored by Americans as well as North Vietnamese, I argue, pose distinct interpretative problems to the reader. This dissertation investigates various Vietnam War--themed texts-novels, drama, and film--to locate and analyze issues contained within these texts and to suggest possible ways to interpret them. The "postmodern" is, according to some theorists, both an historical moment and an aesthetic movement. As such, my investigation analyzes discursive enactments of postmodernity located within these texts as well as postmodern features of the larger cultural moment that these texts allude to. Also contained within the label of "postmodernism," however, is its antithesis and supplement, modernism. Thus, I also address the differing concerns of the modernism and postmodernism

by contrasting two influential modern texts about World War II with two postmodern texts about the Vietnam War. Emerging in the aftermath of a "real" event and authored often by "participants" of the Vietnam War, these postmodern texts can be interpreted as both responses to and "re"-constructions of a historical moment. However, because the idea of language as a vehicle to consensus and truth has been destabilized by postmodern theorists, my analysis addresses both this postmodern distrust of language as well as points out this same skepticism purveyed by many of the authors of Vietnam War literature. I also examine other concerns of postmodernity--globalism, the death of History and other "grand recits;" the fragmentation of self and identity; and the various technological apparatuses that help to define the postmodern moment. Lastly, I examine the differences and overlap between postmodern and postcolonial theories to investigate whether texts authored by North Vietnamese participants of the Vietnam War should be considered "postmodern,"

"postcolonial," or a synthesis of both. I conclude that these texts require equal amounts of both: awareness that postmodernism is a cultural dominant for these North Vietnamese authors but that their lived histories and national identities also require sensitivity to local customs, economics, and politics. [Author Abstract]

45.) **McDowell, K. R.**
The reemergence of medieval word-weaving in Sasha Sokolov's "Shkola dlia durakov": Invoking the word.
Ph.D. dissertation, University of Virginia. 1996.

The present dissertation asserts that certain works of Joseph Brodsky, Andrei Bitov and Sasha Sokolov constitute a distinct aesthetic movement in Russian literature of the sixties and seventies, which, given the insidious effect of the grossly reductive and spurious policy of Socialist Realism, revitalized the Russian language and restored Russian literature to its position as a center of aesthetic and moral power. Brodsky's work, in particular his poems, Ostanovka v pustyne (1966) and Babochka (1972), became the credo for this intensely spiritual activity, while Bitov's early povest', Zhizn'v vetrenuiu pogodu (1963), reintroduced traditional themes and motifs to Russian literature in a wholly apolitical context. The apogee of this movement is Sasha Sokolov's first novel Shkola dlia durakov (1976). Written in the highly

ornamental style of pletenie sloves, of which the best example in Russian literature is Epifanii Premudryi's The Life of St. Stefan of Perm' (c. 1392), Shkola dlia durakov presents three contemporary Russian saints: Nymphea, Pavl/Savl Norvegov and the Nasylaiushchii veter. By virtue of Sokolov's creative use of language and style, these holy figures, powerful cultural icons, extol the virtue of integrity and the spirit of imagination and thereby, redeem and replenish Russian culture. Chapter One provides interesting historical parallels between the cultural milieu in Russia at the time Epifanii Premudryi wrote The Life of St. Stefan and the cultural milieu in Soviet Russia, particularly after the Twentieth Party Congress in 1956, which support my thesis. Chapter Two details Brodsky's "neo-Acmeism" and Bitov's subtle use of intertextual reference, which form a significant part of their contributions to this uniquely apolitical movement. Chapter Three explores the origins and development of the style of pletenie sloves and demonstrates its reemergence in

Shkola dlia durakov, where it creates the saintly figures of Norvegov and the Nasylaiushchii veter. Chapter Four introduces Nymphea, the adolescent schizophrenic narrator of the text, and several female figures and explains their significance in this modern hagiography. Chapter Five concludes this interpretation and discusses the implications for Russian literature and culture. [Author Abstract]

46.) **McLauchlin, V.**
Aestheticism in British architecture: an analysis of the relation between idea and form in the late nineteenth century.
Ph.D. dissertation, CNAA, Architectural Association School of Architecture (United Kingdom). 1992.

This dissertation asserts that Aestheticism was significant for the creation of innovative architectural forms in late nineteenth century Britain and, further, that its engagement with the question of the relation of idea and form is relevant to a general understanding of architecture. Aestheticism has received only cursory treatment in the history of architecture. To appreciate its significance one must understand its philosophical roots and the sociological conditions to which it responded. Romantic ideas suggested that only in the sphere of aesthetics, free from the interests of nature or reason, could one gain a critical appreciation of the position of man in the world. Aestheticism extended this premise, asserting

that the complexity of human interests which characterised modernity could only be expressed in conjunction with formal techniques. The first part of this study investigates the sources of Aestheticism, ranging through the human sciences and across national boundaries to Germany and France, but filtered through the work of Walter Pater who provides the most comprehensive treatment of Aesthetic issues in Britain. For Pater, the concrete work of art expressed a perception of reality which was true despite being provisional under the relativistic conditions of modernity. To achieve the intense perception of reality which Pater promoted, contemporary artists and writers began to investigate the limits of their discrete disciplines and to experiment with the transposition of techniques between the arts. The second part traces the development of Aesthetic formal techniques in literature and painting focusing on the interplay between the arts and the distinctive character of the British response to contemporary conditions. Similarly, the third

part defines the particular qualities of architecture in relation to the other arts, but makes a specific comparison to show that Arts and Crafts ideals cannot account for formal innovations without some influence of Aestheticism. The three case studies show that Aestheticism was a significant determinant of the architects' designs but they also clarify the tensions involved in achieving a formal expression of reality without succumbing to external interests. What emerges is not an Aesthetic Movement but a tendency to use particular formal means to subvert conventional perceptions of architecture. Detailed analysis of Aesthetic formal techniques suggests reasons for the failure to develop a modernist architecture in Britain which histories demonstrating the legacy to Continental modernism overlook. [Author Abstract]

47.) **Meltzer, E.**
Art after words: Conceptualism, structuralism, and the dream of the information world.
Ph.D. dissertation, University of California - Berkeley. 2003.

This dissertation examines the linguistic turn in the visual arts, circa 1970. Many artists--often called "conceptualist"--mobilized language as an artistic strategy, hoping to democratize artistic production and consumption. My project situates this aesthetic movement within the larger field of structuralism and its account of language, defined by Claude Lévi-Strauss, Roland Barthes, and Jacques Lacan, among others. Structuralism represented the notion that all human endeavors were inescapably governed by language's grid-like order, and that sociality could be epistemically mastered through a "science" of the signifier. Structuralisms from many fields of inquiry linguistics, literary studies, social sciences -- believed they could extract the underlying codes of social phenomena from the details that obscured them. Like artists, they

turned to language hoping for a revolution in signifying structures. I argue that the visual arts became a field where these claims were imaged and tested. My dissertation departs from 1970, when the conceptualist project, though increasingly institutionalized, had begun to lose its critical edge. In Chapter One, my examination of MoMA's Information show demonstrates that it was not just language that had emerged onto the visual field, but a 'linguistico-informational' style, within which the artwork was systematized, stripped down, or abbreviated as information conveyed through words. For many artists, therefore, the grid also became the deep structure of the visible world. In subsequent chapters I focus on the work of three practitioners who resisted this style, and questioned the structuralist world-picture and its reconfiguration of visibility as a figure of epistemic mastery. Robert Morris's drawing practice discloses that time, the body, and the phenomenal are sacrificed by the disciplining effects of structural order. Robert Smithson

reveals that when grid-based systems -- perspectival, cartographic, linguistic --are mapped onto the world, their rationalisms crumble, and the illogic of matter produces another kind of sense. Mary Kelly visualizes the ways in which the symbolic order not only shapes our social institutions, but also seduces us with its intellectualisms and scientisms. I conclude by anticipating the lessons which we might take from this linguistic turn, now that the visual world is saturated with the informational aesthetic of digitality. [Author Abstract]

48.) **Mendelssohn, M.**
Henry James and Oscar Wilde: a study of their literary relationship.
Ph.D. dissertation, University of Cambridge (United Kingdom). 2004.

The dissertation's core concern is to explore the literary relationship between Oscar Wilde and Henry James. I use the word "relationship" with purpose: the works they wrote between 1879 and 1916 reveal their sustained and reciprocal engagement. Although they were ambivalent towards each other, these authors shared much: social circles and friends, Irish-Protestant backgrounds, comparable sexual proclivities, a deep attraction to Aestheticism and the theatre, participation in commodity and visual culture, and a lifelong fascination with psychology and material culture. The dissertation contests two pervasive misconceptions: first, that James did not influence Wilde and, second, that James's reaction to Wilde was motivated exclusively by sexual fears. Reinscribing sexuality and influence within a wider nexus of critical concerns, it

shows how their mutual preoccupation coloured their participation in literary and artistic theory, commodification, professionalisation, the drama, interior decoration, and autobiography. Based on these findings, it argues that the rise of a differentiated homosexual identity coincided with significant developments in literary theory, visual culture, the decorative arts, and the renovation of the English stage. The dissertation shows, as Wilde once said, that "an artist is not an isolated fact; he is the resultant of a certain milieu and a certain entourage". Beginning with Aestheticism, the matrix within which James and Wilde flourished, the first chapter chronicles their contributions to the Aesthetic Movement; it also demonstrates that James's early fiction (and its illustrations by George Du Maurier) assimilates fictional Wildean figures. The second chapter shows that Wilde's Intentions directs a two-pronged attack against James's "monstrous worship of facts" and James Abbot McNeill Whistler's worship of fiction, using both to develop a creative method based on interplay

and ambiguity. Focusing on their 1890-1895 plays, the third chapter demonstrates that James and Wilde create an identity-defining discourse of deviance by appropriating hegemonic language and commodities, such as houses and dress. The fourth chapter examines interior decoration in Wilde's American lectures and James's The Spoils of Poynton, and explains why Wilde's doctrine of the House Beautiful and his trials led James to alter his tale. The final chapter explores the intersections between Wilde's De Profundis and James's Autobiography and argues that both authors reject the premise underlying autobiography as a genre (the assumption that it is a self-history) in favour of a "personal history of an imagination" that revises their lives and poetics and reveals a rich association tinged with curiosity, complicity, and distaste. [Author Abstract]

49.) **Meyers, C. K. B.**
Aestheticism and the "Paradox of Progress" in the work of Henry James, Edith Wharton, and Henry Adams, 1893-1913.
Ph.D. dissertation, The University of Tulsa. 1987.

During the last decade of the nineteenth century and the first decade of the twentieth, the industrialized nations of the world struggled to accommodate themselves to "modern" life. "Progress" was the key word throughout most of the nineteenth century, but, as the end of that century neared, the "paradox of progress" came into question--what might the long-term results of pursuing unbridled progress toward an unknown goal actually be? Mechanization, once a force for the betterment of humanity, seemed to be destroying old ways of life without offering a replacement. The world as it had once been now lay in fragments. The best hope for the future was to make a new order out of the chaos of those fragments. Henry James, Edith Wharton, and Henry Adams, in works they completed

between 1893 and 1913, recorded their impressions of the changes taking place in the world around them. One important influence on the way in which they recorded those impressions was British/European Aestheticism, a movement with which all three were familiar. James incorporated the tenets of Theoretical Aestheticism, as described in the work of Walter Pater and other proponents of art for art's sake, into The Spoils of Poynton, The Sacred Fount, The Ambassadors, and The Golden Bowl. In The House of Mirth, The Fruit of the Tree, The Reef, and The Custom of the Country, Wharton concentrated on pointing out the stereotypes of women inherent in the art of the Aesthetic Movement and the attitudes it perpetuated. Adams, more pessimistic than either James or Wharton, saw the world in a state of "decadence." In writing Mont-Saint-Michel and Chartres and The Education of Henry Adams, he borrowed from writers of Decadent Aestheticism the form of "decadent fiction" as a means of expressing his fears for the future. The legacy of

Aestheticism to American literature is not immediately apparent, but it is important nonetheless. Some contemporary texts, such as Thomas Pynchon's The Crying of Lot 49, show the residual effects of Aestheticism and demonstrate the ways in which those effects still function in American literature as a mode of commentary on the "paradox of progress." [Author Abstract]

50.) **Meyers-Riczu, J. F.**
The re-creation of the Byronic hero in the music of Berlioz, Schumann, and Verdi.
M.A. thesis, University of Calgary (Canada). 2011.

Lord Byron was a prominent figure in English Romanticism, and his influence extended beyond his poetic works to include his political actions and persona as one of the nineteenth century's greatest "artist-heroes." However great Byron's influence was at home, his influence on the Continent during his lifetime and after his death was considerably greater. Byron's popularity stemmed partially from the public's fascination with his semi-autobiographical fictional characters who exposed the more sensational details of his lifestyle. Out of this conflation of Byron's personal experiences and his poetic works an aesthetic movement called Byronism emerged in which the Byronic hero plays an important part. The Byronic hero penetrated the consciousness of Hector Berlioz, Robert Schumann, and Giuseppe Verdi, all of whom

were active composers during the mid-nineteenth century and each presents a different facet of the Byronic hero. Berlioz's Harold en Italie portrays the Byronic hero as meditative wanderer suffering from the Romantic malady of Weltschmerz. Schumann's Manfred psychologically portrays the Byronic hero in exile, suffering from a past secret sin that causes an overwhelming sense of anguish and guilt. Finally, Verdi's Il Corsaro presents the Byronic hero as an amalgam of the Noble Outlaw and the Hero of Sensibility. [Author Abstract]

51.) **Miller, M. J.**
Sympathetic Constellations: Toward a Modernist Sympathy.
Ph.D. dissertation, University of California - Berkeley. 2012.

This dissertation examines five modernist writers' revisions of sympathy in response to modernity's changing theories of subjectivity, knowledge, and ethics. I argue that the dominant narrative of modernism as an aesthetic movement that values impersonality over interpersonal interaction overlooks the modernists' interest in developing new theories of emotion and its transmission, an interest inseparable from their aesthetic and philosophical goals. The guiding principle of their explorations of emotion is not empathy, a relatively recent concept whose popularity reflects our contemporary valorization of embodiedness, affect, and fluidity, but rather sympathy, which is currently dismissed as an antique from the Scottish Enlightenment further encumbered by its importance to the Victorians,

with their sentimentality and imperialism. In using sympathy as the starting material for their experiments with fellow feeling, however, the modernists not only situate themselves in an ongoing literary and intellectual tradition, but also emphasize sympathy's structure, distance, and social relationships over the inward-directedness of pity or the immediacy of compassion. The preservation of space is fundamental to sympathy: by maintaining rather than collapsing the distance between the sources and recipients of emotions, sympathy creates an opportunity for experimentation much like that opened by the indeterminacy of language. Taking advantage of this parallel, modernist writers revise sympathy through formal experimentation. The development of new conceptions of emotion and theories of aesthetics were not, as has been assumed, independent processes, but rather two intertwining threads of a complex story about the nature of subjectivity, representation, and experience. I begin with two Bloomsbury writers,

E. M. Forster and Virginia Woolf, because their revisions of sympathy are motivated largely by ethical differences with the Victorians. In "How to Connect," I trace Forster's development from a grudging Victorian liberalism to a quietist liberal irony that leads him to favor negative over positive liberty. To this end, he settles on a passive sympathy that demands tolerance of the other's point of view rather than attempts to improve her station. The next chapter's title, "Putting Ourselves In Mr. Ramsay's Boots," refers to a formal method by which Woolf allows us to experience the "pathos, surliness, ill-temper, charm" of the boots' owner detached from "his concentrated woe; his age; his frailty; his desolation." Faced with sympathy's tendency to 2 balk at the gulfs between the classes or genders, Woolf borrows a technique from Cubism, spreading the traditional content of subjectivity across arrays of common objects in order to form landscapes of emotion detached from individual owners and thus accessible to anyone. In "Unfastening Feeling," the

relationship between subject and object, button and button hole, comes undone: Gertrude Stein lifts the Bloomsbury writers' concern with the nature of the subject and the relative position of the object out of an ethical framework and considers them in terms of aesthetics, countering the limitations subjectivity and objectivity impose on the representation of emotion by breaking down the distinctions between subjects and objects until she is left instead with interchangeable subject-objects. Emotion in Stein's work is no longer a coherent cognitive response to be transmitted between subjects, but a perpetually shifting transmission that arises out of the differences between representations and requires multiple points of origin. For James Joyce and Samuel Beckett, the barriers to sympathy are epistemological. In "An Uncertain Sublime," Joyce reformulates sympathy so that it no longer depends on certainty but rather on a Kantian concept of negative presentation. However, even as Kant's sublime models a means by which Joyce can

avoid reformulating the unknown other in terms of the self, it reduces the other to the Other – to the idea of an enigma. Thus Joyce buffers a totalizing unknowability with the humbler space of error, locating the other's emotion at an indeterminate point within the larger space of the unrepresentable. For Beckett, the minimalist structures of mathematics replace the messiness of human relationships, so that sympathy is an emanation not of individual subjects, but of symmetry. However, because perfect symmetry is no better an antidote to solipsism than a glance in the mirror, we must learn to feel "Sympathy for Surds": for irrational numbers rather than ones or zeroes, rough approximations rather than fully realized subjects or Gayatri Spivak's "originary nothingness." In fact, what creates company and thus the possibility of emotional transmission is the tension between a conception of the real and an imperfect approximation; sympathy is impossible without a feeling of friction or opposition, even if the other who provides it

turns out to be a fragment of the self. One narrative of modernism took T. S. Eliot at his word and banished ethical criticism and the study of emotion from the academy; it seems useful, then, as those outcast fields regain critical attention, to excavate another narrative of modernism, one that is messy, ambivalent, and often tacit, but that reveals the fissures and internal contradictions in our understanding of emotion and its transmission and, in turn, lays the groundwork for a revision of our own conception of sympathy. [Author Abstract]

52.) **Montgomery, D. L.**
William Powell Frith (1819-1909): A reevaluation of his artistic career.
Ph.D. dissertation, University of Missouri - Columbia. 1997.

William Powell Frith (1819-1909) was one of the most popular and successful painters of the Victorian era, yet, because of developments in modernism and the promotion of French-influenced styles, his work, as well as that of many other Victorian artists, has fallen out of fashion and has been nearly forgotten. Rather than applying the standards of modern aesthetics, Frith's artistic career, his style, goals and accomplishments are presented and reevaluated here within the context of his time. With this approach Frith reemerges as one of the key figures of his day. He is credited for his contribution in painting modern subjects before his French contemporaries such as Manet. More importantly, he is not condemned for his continued interest in the British heritage of history, literature and narration. Frith's

reluctance to accept Impressionism and the aesthetic movement is viewed as an appropriate response from one steeped in the Victorian work ethic, trained in the traditional academic style, and sympathetic and responsive to the tastes of private patrons and public viewers. Frith's life and career are presented as an overview, regarding his influences from earlier British painters including William Hogarth, Joshua Reynolds, Thomas Lawrence and David Wilkie. Also emphasized are Frith's stylistic similarities and associations with other Victorian artists: Richard Ansdell, Douglas Cowper, Thomas Creswick, Augustus Egg, William Maw Egley, Alfred Elmore, Richard Dadd, Charles Robert Leslie, Daniel Maclise, William Mulready, Richard Redgrave, Edward Matthew Ward, the Pre-Raphaelites, and others. The misconception that Frith was primarily, if not exclusively, a genre painter is clarified by emphasizing three other important aspects of his career which have received relatively little attention: (1) portraits; (2) literary paintings (including works inspired by

Cervantes, Shakespeare, Moliere, Vanbrugh, Farquhar, Addison, Steele, Gay, Richardson, Fielding, Sterne, Goldsmith, Scott, and Dickens); and, (3) historical paintings, particularly those illustrating anecdotes from the lives of British monarchs and other national celebrities. Whenever possible, photographic reproductions, including numerous details, are provided for all known paintings by Frith, documenting his work as a visual archive. Additional appendices serve as a catalog of all Frith's paintings, with notations concerning questionable attributions. [Author Abstract]

53.) **Mortensen, P.**
High romantics and horrid mysteries: British literature and the struggle with German romance (1798-1815).
Ph.D. dissertation, The Johns Hopkins University. 1999.

During the last years of the eighteenth and the first years of the nineteenth century, British culture experienced a sudden, unexpected, and dramatic influx of novels, plays, ballads and romances translated from the German. Coinciding (albeit uneasily) with the aesthetic movement of Sturm und Drang, the generic category of German romance consisted primarily of literary material rich in supernatural spectacle, heavy on incendiary violence, and rife with piquant sentiment: texts like Bürger's "Lenore," Schiller's The Robbers and The Ghost-Seer, Goethe's Goetz of Berlichingen , and Kotzebue's Lovers' Vows. Received and devoured with avidity by ordinary readers, German sensationalism was also widely and zealously opposed by writers for Britain's outspoken

periodical press, who conflated the genre with revolutionary politics and stigmatized it as aesthetically and ideologically corrupt: an unwholesomely continental, hopelessly decadent, and essentially un-British species of writing. This dissertation explores the ambiguous position of popular German romance within British romantic literature during the time of the Revolutionary and Napoleonic wars. It seeks to explain, for example, why William Wordsworth and Samuel Taylor Coleridge borrowed machinery from the German texts that they elsewhere dismissed as Jacobinical monstrosities beneath notice for romanticism's literary gentlemen; how Walter Scott clove to the terminology of those same extravagant compositions that he also persistently disparaged as characteristic of puerile taste; and to what extent Jane Austen parodied outlandish melodrama while still relying on its stock devices and techniques for her novels' shapes. My working assumption (which is itself continually tested) is that British romantic-period writers both serious and popular involved

themselves (some more than others, and some almost fatally) with the continental literature of terror and titillation. Their deployment of German romance-features entails a process of artistic revitalization and political domestication that is both considerable and complex--much more considerable and much more complex, at any rate, than critics have tended to assume so far. Confronted with the perceived abominations of an illicit and nonconformist genre that both attracted and repulsed them, romantic writers sought to distance themselves from German sentimentalism, even as they appropriated and revised its conventions in their own discourse. Thus, by investigating the ambivalences of a varied group of writers and texts including the familiar and unfamiliar, male and female, high and low, I examine the ways in which the British romantics self-consciously exploited Sturm und Drang's populist trappings to reconstruct a national identity and negotiate ideological change. [Author Abstract]

54.) **Murphy, J. G.**
Brook Hill, 1839-1895: A Virginia villa and its Aesthetic Movement art.
M.A. thesis, Virginia Commonwealth University. 1995.

The history of Brook Hill provides a fascinating view of the Stewarts, a prominent Virginia family, who were patrons of some of the most notable 19th-century Richmond and national architects and builders. Originally built as a Greek Revival dwelling, Brook Hill is a rambling Italianate Villa with Greek and Gothic detailing. Using family papers, land records and physical evidence in the house, it was possible to establish four phases of Brook Hill's evolution. The Greek Revival core of the current dwelling was constructed in 1839-1841. In 1852, the Stewarts enlarged the house, transforming it from a Greek Revival dwelling into an Italianate villa with Greek and Gothic detailing. A discovery in John Stewart's ledger book informs us that Robert Mills provided the plans for this addition. Throughout the 1850s, the Stewarts outfitted

their house and grounds with fashionable rustic, Italianate, Tuscan, and Gothic furniture and outbuildings. In 1871, noted Richmond architects Lybrock & Siebert were hired to design a large addition which proved to be one of the most important High Victorian domestic commissions in war-starved Richmond. Brook Hill experienced dramatic change in the 1880s and 1890s, when the Stewart women redecorated Brook Hill, choosing tiles, wallpaper and stained glass of the Aesthetic Movement. [Author Abstract]

55.) **Nayak, S.**
Citizens everywhere: Modernism, decolonization, and discourses of citizenship.
Ph.D. dissertation, Carnegie Mellon University. 2007.

This dissertation analyzes the construction of citizenship in modernist and post-colonial literary, cultural and political texts. While the diasporic and cosmopolitan roots of modernism are well documented by critics, my project analyzes the ways in which British and American modernists theorize and historicize their affiliation to a chosen or naturalized constituency. I primarily focus on modernist writers' identification with the nation across the registers of nationalism, gender and state. My project also engages with Indian and Carribean perspectives on citizenship as it evolves from a vocabulary of Western liberal notions of self-government within the context of liberal imperialism. My project primarily attempts to address two areas of critical concern. The first pertains to a cultural material framework to

contextualize the varieties of modernist anti-liberalism. More often than not, modernism is theorized as a monolithic aesthetic movement whose anti-liberalism primarily constitutes a deliberate construction of a gap between high-culture and mass culture. This project demonstrates that modernist anti-liberalism vigorously debates the definition of the liberal nation state and forms of interwar nationalism by considering what it means to be a citizen in an era defined by the crisis of the liberal nation-state, the disintegration of the British empire and the rise of the totalitarian state. I begin by demonstrating that critical constructions of Eliot's conservatism, primarily deriving from his self-definition as a British-Anglican and royalist, entirely overlook the forceful confrontation between his poetic aesthetics and inter-war nationalism's definition of citizenship. Similarly, my chapter on Woolf argues that her break with Edwardian materialism comes to constitute a modernist female agency that contests both nationalism and imagines England as a post-

imperial and post-patriarchal territory. I read Pound's turn to Fascist totalitarianism as deriving from, among other things, a specific interpretation of Thomas Jefferson's definition of economic self-determination for the citizens of the newly post-colonial American republic. The second area of concern pertains to the critical treatment of (post)-colonial nationalism that either sees it as a derivative form of Western liberalism or an expression of oppressive xenophobia. My project analyzes Indian colonial discourses and the writings of Pan-African Marxist, C. L. R. James to demonstrate the variety of adaptations and departures from Western liberalism undertaken by anti-imperial nationalism. I am especially concerned with James's particular critique of the typologies of class-hegemony and national community generated by the Western liberal nation state that is often ignored. [Author Abstract]

56.) **Oldford, L.**
The art of socialism: William Morris and the Kelmscott Chaucer.
M.A. thesis, Queen's University (Canada).
2006.

The history of the Kelmscott Press and the Kelmscott Chaucer is discussed with reference to the copy at the Queen's University, W. D. Jordan Special Collections Library. The Chaucer was important to Morris on many levels and it is uniquely representative of the Arts and Crafts Movement ideology. It reflects movement in its form as a physical artefact, historically through its provenance, philosophically through its content and ideologically through its production, design and the beliefs of its creator. The Kelmscott Press afforded Morris the highest realization of his aesthetic ideals, while serving as an archetype of the enlightened workplace, and a source of revenue for his political activism. While emphasis has been placed on Morris as an individual, it is important to realize that he identified himself with groups. While neither the

Arts and Craft Movement nor Morris made a total break with the mainstream culture they felt the mainstream was deeply flawed and exploitive. By reviving crafts and advocating beauty for all they hoped to ease the lives of the poor. Redefining the Arts and Craft Movement as a counterculture provides a new vantage point from which to dissect its impact as more than just a political or aesthetic movement. The clarification and use of Thomas Kuhn's concept of paradigm shows that even if the Arts and Crafts did not have a lasting aesthetic effect it altered the functioning of society and broke ground for countercultures that followed. The Kelmscott Chaucer is beautifully emblematic---it is medieval in quality and inspiration, egalitarian and painstaking in its production, romantic, utilitarian and socialist in the rationale for its creation, an iconic example of the unrecognised force and subversion of the Arts and Crafts Movement. [Author Abstract]

57.) **Ono, A.**
Japonisme in Britain - source of inspiration: J. McN. Whistler, Mortimer Menpes, George Henry, E. A. Hornel and nineteenth century Japan.
Ph.D. dissertation, University of Glasgow (United Kingdom). 2001.

This thesis explores Japanese influences on British Art and will focus on four artists working in Britain: the American James McNeill Whistler (1834-1903), the Australian Mortimer Menpes (1855-1938), and two artists from the group known as the Glasgow Boys, George Henry (1858-1934) and Edward Atkinson Hornel (1864-1933). Whistler was one of the earliest figures who incorporated Japanese elements in his art but never visited Japan; Menpes visited the country and learned Japanese artistic methods from a Japanese artist; Henry and Hornel visited Japan and responded to Japanese photography mass-produced for foreign market. The purpose of this thesis is to consider how Western artists understood and accepted Japanese art as a

source of inspiration. To emphasise and support my view that Japanese art was one of the sources of inspiration for the creation of European art, I will also discuss western influences on Japanese art in the second half of the nineteenth century since this movement, supported by the Japanese government, is a good comparison with Japonisme. The historical background of Japonisme will be discussed in chapter one with a variety of examples taken from decorative art, paintings and cartoons. These examples have been chosen from the works of artists who were associated with the Aesthetic Movement and interested in the improvement of Design, since the early stages Japonisme in Britain was developed by leading figures of these movements. The breadth of the phenomenon is too wide to be included in any one thesis so theatre, music, architecture, sculpture or photography are not included. I will examine the essence of Japonisme by making comparisons between Whistler, Menpes, and Henry and Hornel. For the sake of consistency in

these comparisons, I am going to concentrate on pictorial art. However, Menpes' studio-house with its Japanese decoration is also going to be discussed since despite his wish to recreate an authentic Japanese interior, he did not understand the fundamental basis of Japanese architecture, so that the result was superficial. The artists have been chosen and discussed as follows. [Author Abstract]

58.) **Ovnick, M. W.**
The arts and the craft of persuasion: Developing a language of reform. Los Angeles political and national aesthetic reforms, 1900--1916.
Ph.D. dissertation, University of California - Los Angeles. 2000.

Progressive political reform and the American Arts and Crafts aesthetic reform movement, 1900-1916, framed their objectives as moral crusades. The political restructuring and commercial marketing that they actually carried out cast doubts on their commitment to moral reform. This study proposes that where a condition of press dependency arose, new linguistic techniques were developed for mass persuasion; that it is the techniques, including the seizure of the moral high ground, that distinguish early twentieth-century reform movements and which explain their successes. The conclusion is that the techniques of persuasion as means to political power or commercial success were more significant than

their stated ideological ends. The common denominator of progressivism and of the parallel aesthetic movement was the linguistic methods they employed. The study focuses on the beginnings of both movements when the language of reform was in its experimental phase, confirmed by a look ahead to the peak of each. Two sets of persuasion vehicles were investigated in overlapping study areas, national and single-city. Los Angeles, a city meeting the condition of press dependency in 1900 and renowned for its progressive achievements and vernacular receptivity to the Arts and Crafts movement, provided the test base for the political study and for the convergence of the two movements. Discourse analysis of newspaper editorials, news reports, political pamphlets and published speeches, plus a consideration of political organization strategies, reveals the attainment of political power and the exclusion of portions of the electorate as more important than the surface call for rescuing municipal government from a machine and

restoring it to the people. Against the context of other mass media of the era, methods of semiotic analysis were applied to the text and illustrations of The Craftsman magazine, published nationally from 1901 to 1916. Commercial goals and a shifting set of secondary agendas emerge as more important than the surface theme of moral regeneration. A long-range effect of both movements was to lend moral justification to the shift in family, civic, and consumer values necessitated by urban growth and suburbanization. [Author Abstract]

59.) **Ozturk, T. A.**
Ezra Pound and visual art.
D.Phil. dissertation, University of Oxford (United Kingdom). 1987.

The thesis proposes the wide-ranging importance of visual art to the work of Ezra Pound, and expounds the underlying unity of his aesthetic ideas. I analyse his poetic responses to painting, sculpture and architecture, from A Lume Spento to the Cantos, and show how Pound develops from his formative interests in the Aesthetic movement towards a unified sensibility, defined as pre-Raphael, Pre-Raphaelite, and linear-geometric, governed by spatial and Platonic principles. I discuss the sources of his formal values in Byzantine, Romanesque and Quattrocento art, illustrating the influences of Pater and Ruskin, and examining Pound's attempts to reconcile his conceptual and perceptual heritage to modernism. His early verse reveals the extensive presence of D.G. Rossetti's pictures, while Hugh Selwyn Mauberley simultaneously vindicates his formal taste and

exorcises Aestheticist attitudinising. Vorticism, the logical end of Imagisme and largely an elect coterie of Lewis, Gaudier and Pound himself, heralds a new renaissance in marrying abstraction to figuration, nature to design. Pound's pseudonymous art criticism in the New Age affirms his visual philosophy and assails both Bloomsbury and the Academy. In Paris, Pound synthesises the divergent impulses of Dada and Picabia, Brancusi's formalism, and the machine aesthetic into a new totality of vision. Architecture represents historical contexts for Pound's ideas about the relationship of art to society, while sculpture is the poet's ideal medium. Direct-cutting, with its antique tradition, becomes an analogue for both imaginative values and the aestheticisation of ethics and the political economy. The Renaissance lineaments of power and culture are actualised in the Tempio Malatestiano, where metaphysics are translated into stone, and in the Schifanoia Frescoes, which endow the Cantos' motifs of mythopoeia and history with pictorial

and architectural structures. I examine the nature and extent of Pound's aesthetic influences on the early writings of Adrian Stokes and suggest some significant parallels in their perceptions of Quattrocento art. And I conclude that Pound's visual aesthetic composes a poetic and critical palimpsest of his epoch. [Author Abstract]

60.) **Papalas, M. L.**
A changing of the guard: The evolution of the French avant-garde from Italian Futurism, to Surrealism, to Situationism, to the writers of the literary journal "Tel Quel".
Ph.D. dissertation, The Ohio State University. 2008.

The avant-garde is an aesthetic movement that spanned the twentieth century. It is made up of writers and artists that rebelled against art and against society in a concerted effort to improve both, and their relationship to one another. Four avant-garde groups, the Futurists, the Surrealists, the Situationists, and the writers of the journal Tel Quel, significantly contributed to the avant-garde movement and provided perspective into whether that movement can exist in the twenty first century. The first Futurist Manifesto , published in the French newspaper Le Figaro in 1909 by Philippo Tommaso Marinetti, instigated the avant-garde wave that would be taken up after the Great War by the Surrealists, whose first 1924 Manifeste du

Surréalisme echoed the Futurist message of embracing modern life and change through art. The Surrealists, however, focused more on Marxism and psychoanalysis, developing ideas about life and art that combined these two ideologies in order to link the improvement of society with the unconscious individual experience. The Situationists, whose group formed in 1957, took up the themes of social revolution and freedom of the unconscious, developing a method for creating situations that were conducive to both of these things. The writers of the journal Tel Quel , who published from 1960-1982, claimed to be part of this literary history, and continued the discussions begun by the others, providing insight into how language and its structures, which paralleled those of society, needed to be changed in order to change society. This dissertation aims to define the twentieth century avant-garde and to inquire about its existence in the twenty-first century. The first chapter examines the socio-historic and philosophical context from which

these groups emerged and against which they reacted. The second and third chapters analyze the themes of the city and politics in avant-garde works to demonstrate the aims and ambitions of the groups. The fourth chapter looks at avant-garde membership from a gender perspective, focusing on the example of the female Surrealist poet, Joyce Mansour. Taking these criteria into consideration, the conclusion opens a discussion about the relevancy of these groups nearly a century after the publication of the first Futurist Manifesto and looks into the possibility of a twenty-first century avant-garde. [Author Abstract]

61.) **Paulson, E.**
Farthest away, deepest within.
M.F.A. thesis, The University of the Arts. 2013.

This paper examines my interdisciplinary art practice and its reliance on time-intensive processes through a discussion of concepts, practice, and development. Discussed are the research and philosophies underlying the concepts of this body of work, including the aesthetic movement of the Sublime and the nature of humanity. This discussion contextualizes my practice alongside several contemporary artists examined in this paper: Vija Celmins, Olafur Eliasson, Ran Ortner, James Turrell, and Robert & Shana ParkeHarrison. I detail how their practices and concepts relate to and inform my own, including the metaphors found in my choice of time-intensive practices, and how they serve to embed the work with my content. Lastly, my artistic development and growth prior and throughout graduate school is also traced, and how these changes resulted in

the culmination of this body of work. At the conclusion of my paper and bibliography are my curriculum vitae, artist's statement, images, and image list. [Author Abstract]

62.) **Pendleton, M. B. L.**
Bedford Park: An introduction to further study.
Ph.D. dissertation, Northwestern University.
1981.

Bedford Park has long been regarded as one of the most significant communities by the Aesthetic Movement. So far, its importance has lain basically in three areas--its architecture, its residents, and its "plan." Yet even though Bedford Park has been the subject of several studies which have established its importance in all of these areas, none has approached a scholarly thoroughness. It is to be hoped that this study has provided the first systematic analysis of Bedford Park and that, moreover, it has laid the groundwork for additional enquiry into this highly significant community. During the course of this investigation, it became increasingly evident that there was a tremendous reservoir of material still extant on the community which had gone virtually untapped. Sources used in this study include diaries, unpublished drawings, letters,

biographies, and art and architectural journals. In addition, a photographic study was made of many of the suburb's buildings. A careful examination of the community revealed certain surprising facts. First of all, its transformation into the architectural showplace of the Aesthetic Movement has proven to have been far more complex than is usually presumed, thus necessitating a redefinition of the roles of Godwin and Shaw. Second, it was discovered that its reputation within the aesthetic Movement was determined to a substantial degree by yet another man, Maurice B. Adams, whose crucial role at the suburb had curiously gone igonored in all previous studies. Finally, it became evident that the accomplishments of Bedford Park's residents deserve far more recognition than they are usually accorded. During its intellectual heyday in the '90's, the suburb attracted some of England's leading artists and writers, whose achievements encompassed many fields, among them decorative arts, book design, and drama. In fact, the phenomenal achievements then

realized at the suburb are without parallel in any other community in England at this time. It is to be hoped that this examination of Bedford Park's architecture, residents, and community life has clearly demonstrated why it should be regarded, not just as another community of the Aesthetic Movement, but rather as the primary community of that movement. [Author Abstract]

63.) **Potolsky, M. D.**
Teaching decadence: Aestheticism and the ends of education in Gautier, Masoch, and Pater.
Ph.D. dissertation, University of California, Irvine. 1997.

This dissertation examines the interrelation between imitation and education in texts by three major figures from the aesthetic movement of the late nineteenth century: Theophile Gautier, Leopold von Sacher-Masoch, and Walter Pater. At least since Plato excluded the poets from his republic, imitation and education have stood in an uneasy relationship to one another. Education relies on the resources of imitation; but imitation has a tendency to exceed in its effects the message that the teacher wishes it to carry. In chapters on imitation in educational theory, and on educational narratives in texts by Gautier, Masoch, and Pater, this dissertation argues that aestheticism, far from constituting a mere valorization of art over life, offers a challenge to

conventional uses of art in education. The dangerous teachers and misled students who populate aestheticist narrative dramatize the extent to which education is both enabled and disabled by imitation. But rather than seeking, like Plato, to exclude imitation from education, aestheticism insists that imitation is inevitable, and that the teacher must acknowledge, rather than seek to efface, the distinction between life and art. [Author Abstract]

64.) **Potts, S. W.**
F. Scott Fitzgerald: His career in magazines.
Ph.D. dissertation, University of California - Berkeley. 1980.

One critical issue in the study of F. Scott Fitzgerald that has received frequent mention but little in-depth analysis concerns the extent to which Fitzgerald geared his magazine fiction to editorial parameters and audience preferences. Since Fitzgerald spent the bulk of his career writing for popular markets, this matter is central to an accurate evaluation of the author's stature as artist, professional, and cult figure. A perusal of Fitzgerald's publication history shows that three magazines functioned as primary markets for his short works at different stages of his career. The Smart Set, edited by H. L. Mencken and George Jean Nathan, provided Fitzgerald his first professional sales in late 1919. This journal shared with the Ivy League subculture of the World War I era a fascination

with the European aesthetic movement; increasingly, however, it reflected in its pages not only the droll, aristocratic cynicism of aestheticism but the pessimism of the naturalists that Mencken was then championing. The influence of both aestheticism and naturalism is evident in the stories Fitzgerald published in The Smart Set, as well as in the longer works he produced in this phase of his career, which ended in 1923. Though The Saturday Evening Post had published half a dozen stories by Fitzgerald during his Smart Set period, it did not become his primary market until 1924. The most successful magazine of the era, it was also the most important market of Fitzgerald's career; the author appeared therein seventy times from 1920 through 1937, though most of his work for the magazine was done in the decade between The Great Gatsby (1925) and Tender is the Night (1934). Since the Post itself closely monitored the mass mind, Fitzgerald's long association with

this periodical says a great deal about the nature of his popularity and his relationship with the middle-class mainstream of American thought, not to mention his practice of writing as profession and art. The Post has been blamed for a number of this author's artistic lapses, though close analysis of the magazine's contents over time suggests that this judgment may be unfair. His third major market was Esquire, a Depression-bred journal whose editor much admired Fitzgerald and welcomed his work. Esquire thus became virtually the sole outlet for Fitzgerald's prose in the last years of his career. With relatively few editorial restrictions, Fitzgerald could write presumably whatever he wanted to write; the results say much about the state of the author's mind and art in the thirties. Fitzgerald published as well in a number of other magazines, mostly in the periods between major markets. As a group, these publications in minor markets provide a composite of Fitzgerald's reputation among his contemporaries and of the manner in which he served that public image.

Taken in toto, Fitzgerald's magazine career puts into perspective his more often studied major works as well as his standing as an important and representative figure of the decades between the wars. [Author Abstract]

65.) **Poueymirou, M. L. R.**
The sixth sense: synaesthesia and British aestheticism, 1860-1900.
Ph.D. dissertation, University of St. Andrews (United Kingdom). 2009.

This thesis is an interdisciplinary examination of the emergence of synaesthesia conceptually and rhetorically within the `art for art's sake' movement in mid-to-late Victorian Britain. Chapter One investigates Swinburne's focal role as both theorist and literary spokesman for the nascent British Aesthetic movement. I argue that Swinburne was the first to practice what Pater meant by `aesthetic criticism'; and that synaesthesia played a decisive role in `Aestheticising'; critical discourse. Chapter Two examines Whistler's varied motivations for using synaesthetic metaphor, the way that synaesthesia informed his identity as an aesthete, and the way that critical reactions to his work played a formative role in linking synaesthesia with Aestheticism in the popular imagination of Victorian England. Chapter Three

explores Pater's methods and style as an `aesthetic critic'; Even more than Swinburne, Pater blurred the distinction between criticism and creation. I use `synaesthesia'; to contextualise Pater's theory of "Anders-streben", and to further contribute to our understanding of his infamous musical paradigm as a linguistic ideal, which governed his own approach to critical language. Chapter Four considers Wilde's decadent redevelopment of synaesthetic metaphor. I use `synaesthesia'; to locate Wilde's style and theory of style within the context of decadence; or, to put it another way, to locate decadence within the context of Wilde. Each chapter examines the highly nuanced claim that art should exist for its own sake and the ways in which artists in the mid-to-late Victorian period attempted to realise this desire on theoretical and rhetorical levels. [Author Abstract]

66.) **Primamore, E.**
The invention of "Michael Field": A dandy-androgyne, modernism and the aesthetic world of Katherine Bradley and Edith Cooper.
Ph.D. dissertation, City University of New York. 2005.

My study concerns "Michael Field" as a modernist project. This pseudonym belongs to late nineteenth century English aunt and niece literary collaborators Katherine Bradley and Edith Cooper. By contextualizing "Michael Field" culturally, critically, and biographically, what emerges, I offer, is how female collaboration in the guise of a male identity creates a new genre through a merging of a lived reality with the production of that reality in writing. Focusing on the aesthetic movement, including theories of the dandy, this study analyzes the appropriation of a "gay male" discourse by two "lesbian" poets as a complementary discourse to contemporary theories of androgyny and queerness in the articulation of radical women's voices and queer desire. Utilizing Wildean notions of art and

Butlerian notions of gender, I explore the ways in which Bradley and Cooper construct "Michael Field" as a dandy-aesthete-persona. My study begins with an analysis of "Michael Field's" artistic aim through a consideration of Bradley's The New Minnesinger, unpublished letters, and Virginia Woolf's A Room of One's Own. This section also concerns biographical material, which suggests political issues as opening up a space for "Michael Field's" aesthetic investigations. An historical overview, with a focus on gender politics, suggests a theory of collaboration that explores the complexities of the formation of a male poetic identity for two women poets within the context of emerging identities of the New Woman and homosexual aesthete. Poems from Wild Honey, Underneath the Bough, Sight and Song, and Dedicated as well as unpublished poems are read as life enacted in art. Long Ago is analyzed with particular attention to Hellenism, which is read as a discourse of female erotic desire. This work is situated in the context of "Sapphic

Modernism." The study concludes with a look at the plays and religious poetry which are further analyzed as sites of female transgressions, a subject also produced through Bloomsburyian literary experimentation in the plays. By tracing the evolution, function, and multiple meanings of this identity, I hope to show that the public and personal desires of two women poets, filtered through "Michael Field," forged an innovative sphere of literature representative of modernist literary enterprises of the next generation of women. [Author Abstract]

67.) **Pysnik, S.**
Camp Identities: Conrad Salinger and the Aesthetics of MGM Musicals.
Ph.D. dissertation, Duke University. 2014.

This dissertation seeks to position the music of American arranger-orchestrator-composer Conrad Salinger (1901-62) as one of the key factors in creating the larger camp aesthetic movement in MGM film musicals of the 1940s and 1950s. The investigation primarily examines Salinger's arranging and orchestrating practices in transcriptions and conductor's scores of musical numbers from MGM films, though some scores from Broadway shows are also considered. Additionally, Salinger's style is frequently compared to other arrangers, so as to establish the unique qualities of his music that set it apart from his contemporaries from both a technical and an aesthetic standpoint and that made it desirable as an object of imitation. By inquiring into his musical practices' relationship to his subjectivity as a gay person in the era of "the closet," this analysis both proposes and

confirms Salinger's importance to the MGM camp aesthetic. With the concept of "musical camp" thus established, the dissertation subsequently demonstrates its capacity to produce new readings of the politics of national belonging and gender that manifest in various musical numbers. [Author Abstract]

68.) **Reed, C. G.**
Re-imagining domesticity: The Bloomsbury artists and the Victorian avant-garde. (Volumes I and II).
Ph.D. dissertation, Yale University. 1991.

To re-imagine domesticity: the phrase implies a dual process of reconceiving and expressing through imagery ideas of a new home life. This, I argue, is the basic project of the Bloomsbury artists--Roger Fry, Vanessa Bell, and Duncan Grant--who built on the foundation of aesthetic activism laid by their Victorian predecessors. My approach combines close visual analysis of individual objects or projects with examination of relevant textual sources: the artists' letters, the Formalist aesthetic theory developed in the writings of Roger Fry and Clive Bell, and the writing of Bloomsbury figures including Lytton Strachey, E. M. Forster, and Virginia and Leonard Woolf. A theoretical introduction uses the opposition between concepts of "heroism" and "housework" to establish the ideological difference that separates the domestic focus

Bloomsbury and its Victorian antecedants from what became the mainstream of modernism in the arts. The first two chapters then place Bloomsbury in the context of the Arts and Crafts Movement and the Aesthetic Movement from which the group emerged. There follows an examination of the development of Bloomsbury's domestic modernism between 1904-1914.

Throughout, questions of sexual identity are a central focus in this study of women, gay men, and others who imagined (and imaged) new ways of living outside conventional domestic norms. [Author Abstract]

69.) Roberts, E. E.
Japanism and the American aesthetic interior, 1867--1892: Case studies by James McNeill Whistler, Louis Comfort Tiffany, Stanford White, and Frank Lloyd Wright.
Ph.D. dissertation, Boston University. 2010.

This dissertation argues that, between the 1876 Philadelphia Centennial Exposition and the 1893 World's Columbian Exposition in Chicago, American interior designers used Japanism to present themselves and their patrons as tastefully modern and artistic without being ostentatious, an issue considered of paramount importance during the aesthetic movement. Yet in this period American Japanists' relationship with their model evolved from a more superficial appropriation of surface motifs to an emulation of the underlying structure of Japanese prints and architecture, as the four case studies here demonstrate. Chapter 1 addresses James McNeill Whistler's house at No. 2 Lindsey Row in London, where he lived between 1867 and 1878. There, Whistler first used an additive Japanism, in

which Japanese objects were installed in a dense, typically mid-Victorian manner, and later a more austere version of the style, influenced by the simplicity and close relation to nature he admired in Japanese prints and architecture. Chapter 2 focuses on Louis Comfort Tiffany's Bella Apartments in New York, his residence between 1878 and 1884. In that space, Tiffany also experimented with different kinds of Japanism, creating some rooms with a brilliantly ornamented aesthetic indebted to Japanese lacquer and textiles, and others that were plainer and inspired by fundamental Japanese design principles. Chapter 3 discusses Stanford White's dining room for David and Ella King's house, Kingscote, in Newport of 1880-1881. There, White advanced the emulation of Japanese architectural elements, unifying the room not only through Japanesque simplicity and geometricization, but also through the appropriation of traditional Japanese forms. Chapter 4 treats Frank Lloyd Wright's interiors for Adler and Sullivan's James and Helen

Charnley house in Chicago of 1891-1892. In such early works, Wright brought Japanese elements to the interior architecture of entire houses for the first time, creating the sort of spare, open, modular, close-to-nature spaces that he believed he saw in Japanese buildings. Thus, while the first American visitors to Japan after 1854 judged that the plain, open, wooden, asymmetrical structures they saw there were not architecture, by 1893 those very characteristics were a major influence on American interior design. [Author Abstract]

70.) **Ronchetti, A. L.**
The artist-figure, society and sexuality in Virginia Woolf's novels.
Ph.D. dissertation, The University of North Carolina - Chapel Hill. 1993.

This study of artist-figures in Woolf's novels explores the relationship between aesthetic productivity and the artist's degree of involvement in social and sexual life. Of particular interest are the constrictions imposed upon aesthetic productivity by gender roles and the demands of empire. Referring to the opposed Western traditions of the artist as Ivory Tower recluse and as one immersed in life's Sacred Fount described by Maurice Beebe, this study traces the evolution of Woolf's artist-figures from the retiring figures of the earliest novels to the socially and sexually engaged of the later novels. The introduction locates the sources of Woolf's lifelong preoccupation with the artist's relationship to society in her family heritage, her exposure to Walter Pater and the aesthetic movement, and the philosophical and aesthetic

interests of the Bloomsbury group. Woolf's earliest novels reflect the influence of Pater, aestheticism and the Ivory Tower tradition in the preference of her aspiring young artist-figures for the sequestered life and the Platonic search for a reality beyond the quotidian. The artist-figures of the later novels simultaneously show increased social and sexual involvement and growing marginality, reflected in their class status, nationality, gender or sexual orientation. Both trends reach their extreme embodiment in Miss La Trobe of Between the Acts. Woolf's portrayal of the artist-figure increasingly as outsider exhibits not only Pater's ongoing influence, but also her growing preference for artistic anonymity and her evolving political consciousness, which privileges outsider status for what she believes to be its more objective view of society. As socially and sexually engaged outsiders, the artist-figures of Woolf's late novels nonetheless continue to be hindered by gender roles and societal expectations. Sensitive observers of an increasingly mechanized culture

that has become inhospitable to aesthetic productivity, they are valued more for their utility to the empire than for what they are capable of achieving as disinterested artists. [Author Abstract]

71.) **Sattaur, J.**
Representations of childhood: motifs of child and trickster in selected mid-Victorian to fin de siècle prose fiction.
Ph.D. dissertation, The University of Wales, Aberystwyth (United Kingdom). 2008.

This thesis reads Victorian *fin de siècle* literature through perceptions of childhood, as revealed in the patterns of two archetypes: the Trickster and the Child. It examines a connection between the chaotic and the idealistic symbolic representations of childhood, as represented by these two archetypes, and as seen in some of the newly-developed cultural formations of the Victorian *fin de siècle*. Victorian anxieties about change are linked closely to anxieties about childhood, procreation, and maturation, revealed as a progression of patterns of the two archetypes in a range of children's and adult's texts. For each decade I examine one adult text and one children's text, comparing how cultural formations relating to body, mind, soul and society, explore symbolic renditions of

generationality through the Child and Trickster archetypes. Two 1860s texts provide a mid-century marker, Collins's *The Moonstone*, revealing aspects of the economic-sociologic impact of Empire on society, linked with Carroll's *Alice in Wonderland*, seen in terms of perceptions of madness and normality which shaped the field of psychoanalysis: for the 1880s, I examine Stevenson's *Jekyll and Hyde* and its use of evolutionary theory, linked with Wilde's *The Happy Prince and Other Tales*, discussed in terms of the aesthetic movement; finally, for the 1890s, George MacDonald's *Lilith*, is considered in relation to aspects of spiritualism, linked with Kipling's *The Jungle Books*, viewed in terms of anthropology and its exploration of connections between primitive life, animal life, and progress. By examining how these two archetypal ways of representing childhood progressed from being distinct to being merged in literature, this thesis hopes to demonstrate the ways in which some of the emergent intellectual formations which have

come to represent change in the *fin de siècle* period were inherently concerned with perceptions of childhood as they represented both the promise and the threat of the future. [Author Abstract]

72.) **Shaup, K. L.**
Disciplining the senses: Aestheticism, attention, and modernity.
Ph.D. dissertation, University of Oregon. 2011.

In the second half of the nineteenth century, the Aesthetic Movement in England coalesced literary and visual arts in unprecedented ways. While the writers associated with the Aesthetic Movement reflected on visual art through the exercise of criticism, their encounters with painting, portraiture, and sculpture also led to the articulation of a problem. That problem centers on the fascination with the attentive look, or the physical act of seeing in a specialized way for an extended period of time that can result in a transformation in the mind of the observer. In this dissertation, I consider how Dante Gabriel Rossetti, Henry James, and Oscar Wilde utilize the attentive look in their poetry, fiction, and drama, respectively. As I argue in this dissertation, the writers associated with the Aesthetic Movement approach and treat attention as a new tool for self-creation and self-

development. As these writers generally attempt to transcend both the dullness and repetitiveness associated with modern forms of industrialized labor as well as to create an antidote for the endless distractions affiliated with the modern urban environment, they also develop or interrogate systems for training and regulating the senses. What these writers present as a seemingly spontaneous attentive engagement with art and beauty they also sell to the public as a specialized form of perception and experience that can only be achieved through training or, more specifically, through an attentive reading of their works. While these writers attempt to subvert institutional authority, whether in the form of the Royal Academy or the Oxford University system, they also generate new forms of authority and knowledge. Even though the Aesthetic Movement is not a homogeneous set of texts and art works, the Aesthetic Movement can be characterized in terms of its utilization of attentiveness as a way to both understand and create modern subjectivity. [Author Abstract]

73.) **Spurgeon, J. L.**
Western aesthetics and avant-garde trends in the formation of modern nihonga.
Ph.D. dissertation, The University of Wisconsin - Madison. 2010.

This dissertation explores the efforts of Ernest F. Fenollosa (1853-1908), an American hired to teach philosophy and political science at Tokyo University in 1878, and his former student and colleague, Okakura Tenshin (1862-1913), to re-envision and restructure the Japanese art world during the Meiji period (1868-1912). Although both men viewed their activities as a way of preserving and celebrating the authentic native artistic tradition and have been approached in this way by later scholars, the notion of a unified national art only developed in response to Western cultural hegemony. And, while nihonga, literally "Japanese painting," a term coined by Fenollosa by 1882, was understood as the polar opposite of yoga or "Western painting," it was established on the same organizational and conceptual basis as its rival, and it employed a

similar terminology. Both Fenollosa and Tenshin employed Western models to restructure Japanese art. Realizing that Japanese art would always be considered inferior when viewed according to Western representational aims, Fenollosa employed a model espoused by members of the Aesthetic movement and praised it for its skillful arrangement of lines, color, and shading. In designating these qualities as "ideal," he was also attempting to synthesize the aesthetic approaches of the German philosophers G. W. F. Hegel (1770-1831) and Immanuel Kant (1724-1804). Unlike his mentor, Tenshin was less interested in the relationship of Japanese art to incipient Western modernism and more in its role in communicating a nationalistic message to the newly enfranchised citizenry. To this end, he promoted the ideologically dense genre of history painting, long considered most prestigious within the traditional Western academic hierarchy. He later attempted to adapt Western Symbolist modes, which attempted to combine the literary and

visual arts in the production of what came to be known as "Idealist painting". While the specific innovations promoted by Fenollosa and Tenshin were not particularly successful, they encouraged artists to expand their repertoires and begin to envision themselves in a manner similar to their Western counterparts. [Author Abstract]

74.) **Srivastava, S.**
Fashioning the decorative body in late nineteenth-century English and French painting: Artifice, color and style.
Ph.D. dissertation, New York University. 2006.

This dissertation examines the significance of costume as it intersects with decorative art in English and French painting in the later nineteenth and early twentieth centuries. It demonstrates the malleability of the decorative concept during this period and the way in which artists seized the nebulousness of this 'movement' to accomplish different aesthetic goals. The first part of my project, Morris, Rossetti, Burden and the Nabis: The Decorative 'Force' of Artistic Dress, focuses on "artistic dress" as articulated by the Aesthetic Movement. Despite the English insistence that their version of female costume was based upon the idea of a 'naturalized' body, "artistic dress" was embedded within the trap of artifice. Their construction of the 'natural' body was based upon horticultural science, especially the domestication of exotic

flora through acclimatization. This aesthetic ideal of costume is then examined as a precedent for the loose costumes depicted in Nabi pictures and within this same context of acclimatisation. Here the trellis and greenhouse operate as potent symbols of fin-de-siècle French femininity. Part two, Bodies of Color: Costume in the Painting of Gauguin and Van Gogh, examines the role that missionaries played in Gauguin's juxtaposition of the Polynesian pareu and the English missionary dress. Gauguin's emphasis on color and decorative patterns reflects the native Polynesian penchant for decoration prohibited by the English through their missionary efforts to convert Tahitians to Christian propriety. Gauguin resurrected this Polynesian aesthetic to 'preserve the native culture.' The next chapter examines Van Gogh's preoccupation with various forms of energy that he translated through the careful juxtaposition of colors. He produced 'electric' effects that maximized color's decorative possibilities referred to as 'brilliant coats of color.' Finally, Style and Paint in the Early

Twentieth Century, examines the 'accessory' as represented in Matisse's Woman in Hat in relation to a group of Picasso's paintings of the 1930s. These chapters focus on the phenomenon of an ever-changing artistic style within the context of fashion's reliance upon its own obsolescence: fashion is predicated on the recycling of its own history. Picasso's representations of hats during this period also echoes Matisse's masterpiece, Woman in Hat. [Author Abstract]

75.) **Sultanian, M. P.**
Martha Graham engages the body and its dances as a path into the unconscious.
Ph.D. dissertation, Pacifica Graduate Institute. 2013.

How does Martha Graham conceptualize and then give expression to information delivered by Psyche through her body and the choreographic process? This is a study of the relationship of Psyche and Soma considered through examination of Graham's choreographies as expression of their union. This study seeks to participate in discourse on the process of melding the Unconscious and the body through the art of choreography. Three choreographies of Graham as text in the symbolic form--offered through the aesthetic movement phraseology presented by the choreographer--are introduced and interpreted, opening doors that invite discourse upon the subject. Hermeneutics--a methodological approach in which interpretation of text is used to gather insight into the meaning of the text--is utilized to foster engagement in

Graham's choreographies. To explore meaningful forms in dance as text, the research creates a frame through which to cultivate, interpret, and integrate information from Graham's choreography. What becomes evident is the complementarity of artistic processes and the unfolding of qualitative research practices and the interpretive activities fostered. Interpretation becomes a deep connectedness with the research material, in this instance the dance methodology, movement language and range of Graham and the manner in which she utilizes aesthetic movement as a path into the Unconscious. The choreographies Errand Into the Maze (1984), Lamentation (1930), and Light--Part 1 (2010) demonstrate how, as the dancer weaves the choreographic sequences into the performance, the Body becomes expressive of Psyche and is ultimately moved and informed by Psyche. Graham invites the onlooker to peer into the pathways leading her to thematic content and subject matter of Psyche, which she then fashions into choreography. Graham's systematic

approach to setting emotion into motion on stage becomes evident. The implication of this study for Depth Psychology entails an invitation to include Soma in the study of Psyche. An exploration of Graham's choreographic repertoire reveals a profound range of self-expression, not bound merely to the spoken word. Hers--articulation and manifestation of subjective information derived from the Unconscious, performed through choreographic ventures--is a sensory-integrative and self-expressive experience. [Author Abstract]

76.) **Susser, E. A.**
Modern selves/Romantic souls: The aestheticism of Pater, Wilde, and Yeats.
Ph.D. dissertation, University of Virginia. 1997.

My dissertation focuses on the central strain of the aesthetic movement in England, codified in the 1870s by Walter Pater and subsequently developed and transformed by Oscar Wilde and W. B. Yeats. This aestheticism takes the form of a series of binary oppositions, both internal (the writing of each artist thrives on the tension generated by conflicting impulses) and external (each writer repudiates Romanticism and Victorianism while paradoxically remaining rooted in the Romantic and Victorian traditions). Focusing primarily on The Renaissance, I begin the dissertation by exploring the contradiction between Pater's desire to return to a pre-Romantic age and his belief that any movement away from Romanticism must begin from a post-romantic perspective. The opposition he posits between classicism and romanticism is common

to Victorianism and to modernism, but I demonstrate how Pater makes this dichotomy his own. Reconceiving Pater's aestheticism in social terms, Wilde reveals the politically, culturally, and morally subversive nature of the aesthetic doctrine. Using the critical essays collected in Intentions as well as "The Soul of Man under Socialism," I demonstrate that Wilde's paradoxes take the form of an opposition between the individual and the community. While professing to exalt the artist over the philistine, Wilde relied heavily upon the middle-class public: both externally (his reputation and fortune depended upon its patronage), and internally (his epigrammatical art generated its power and panache only in the context of Victorian cliches and platitudes). I conclude by recapitulating the aesthetic of Yeats's last works as a reaction to modernism. Using his final poems (especially "Under Ben Bulben") and essays (particularly On the Boiler), I argue that Yeats does not repudiate but extends his earlier aestheticism, elaborating

a Paterian dichotomy between the poems of tragic joy and the poems of self-mourning. Yeats's early enchantment with Pater and Wilde, I contend, helps explain his affinities with fascism. [Author Abstract]

77.) **Sussman, M. B.**
Stylistic Virtue in Nineteenth-Century Fiction.
Ph.D. dissertation, Harvard University. 2013.

To many readers, the Victorian novel is synonymous with moral insight and Victorian criticism with moral philistinism. While the novel remains celebrated for its complex treatment of decision-making and sympathy, the evaluative judgments of Victorian critics have been dismissed as thematically reductive and imprecise. However, this study argues that the virtue terms that pervade Victorian discourse-- words like "natural," "manly," "lucid," and "sincere"--invest sentence-level stylistic properties with ethical value because they embody aesthetic character. Rather than focus on the novel's action, characters, or themes, these "stylistic virtues" ascribe moral significance to "literariness" itself. The first part of this study recovers the defining but hitherto unnoticed influence of virtue theory on nineteenth-century philosophy and criticism. Inspired by Aristotle,

key figures such as Hume, Mill, and Green imagined ethics as a kind of aesthetics rooted in the subjective admiration of qualitative excellence; concurrently, the most important Victorian critics--Ruskin, Arnold, Pater, and Wilde--treated aesthetic properties as embodiments of virtuous ways of being and seeing. The centrality of style within the Aesthetic movement can only be explained as an outgrowth of this conceptual framework: style rose to prominence not, as is commonly argued, as a reaction against the reductive moralism of mid-Victorian criticism, but rather as its logical extension, becoming the locus for the Hellenic values that had been evacuated from mainstream utilitarianism. In ethical criticism, judgments about style typically reflect claims about a novel's represented action or governing tone. A series of case studies challenges this approach by showing how stylistic virtues convey an aesthetic character that may differ from other kinds of content. Thackeray's conventionalized style is protean and adaptable, finding "grace" in

the "humbug" he normally abhorred. The virtues of Trollope's disappearing style ("ease," "lucidity," and "harmony") are only indirectly connected to the goals of morally didactic realism. In contrast, Meredith, derided as difficult or precious, sought a stylistic analogue in "fervidness" for the inevitability of sexual conflict. Taken together, these stylistic virtues offer a bridge between moralism and formalism in the analysis of novelistic prose, emphasizing the distinctiveness of aesthetic appreciation without depriving it of ethical force. [Author Abstract]

78.) **Sweeney, M.**
Hiding Genre Distinctions and Finding Gender Divides: An Iconographic, Formal, and Contextual Analysis of James Tissot's "Hide and Seek".
M.A. thesis, The University of North Carolina - Chapel Hill. 2012.

Resisting the standard categories of genre, James Tissot's Hide and Seek operates within the contexts of studio portraits and domestic scenes. Thus, while registering the character and status of the artist, the painting presents a particular image of the domestic realm and familial relations. It also lends itself to a gendered reading, which is here informed by a discussion of the Aesthetic Movement, Japonisme , and the ties between each of these movements and contemporary conceptions of femininity. In the face of Aestheticism's perceived threat to the masculinity of artist and studio, Hide and Seek reaffirms the ideology of separate spheres. It achieves this end by depersonalizing, objectifying, commodifying, and enclosing the

female inhabitants of Tissot's home-studio while evoking an invisible, externalized male presence that seems to resist capture and domestication and to maintain subjectivity, agency, and mobility. [Author Abstract]

79.) **Thomson, J. W.**
From aestheticism to the modern movement: Whistler, the artists' colony of St. Ives and Australia, 1884--1910.
M.Phil. thesis, University of Hong Kong (Hong Kong). 2004.

This study of Whistler, the artists' colony of St Ives and Australia 1884-1910 is a compendious analysis of the complex relationships between the British American artist James McNeill Whistler and the aesthetic movement, between Whistler's aestheticism and the development of modernist art practice both in England and Australia, between the art establishment and the development of a modern market for art, between artists and their social, economic and political environment, between artists and their audiences, and between notions of artistic identity and nationalism. These are not simple binary concerns but multilateral issues that impact on each other in many different ways. The artists' colony of St Ives in England at the end of the nineteenth and the beginning of the

twentieth century is an important site for exploring all of these issues. Whistler was of central importance to the establishment of the artists' colony of St Ives. His aestheticism and assertion of the centrality of individual artistic identity gave the colony not just a style and motif but a whole raison d'être Moonlit paintings and seascapes became vehicles for exploring particular concerns with aspects of modern life and formalist aspects of contemporary art practice. A number of Australian artists also played an important role in the on-going vitality of the artists' colony of St Ives. Concomitantly, their experience of living and working at St Ives was fundamentally important in facilitating the transmittal of important developments in contemporary art to Australia at a decisive time in its cultural development. [Author Abstract]

80.) **Truax Yarger, C.**
Louis H. Sullivan: The Aesthetic Movement, Classical Monumentality and the Skyscraper.
Ph.D. dissertation, Virginia Commonwealth University. 2014.

This dissertation looks at some of the most famous structures by talented and cryptic American architect Louis Sullivan (1856-1924) for fusions of Aesthetic Movement surfaces and two-part Classical Monumentality. For architects, the Aesthetic Movement allowed for a greater amount of freedom when it came to sources, massing, and ornament, which resulted in the creation of more highly textured surfaces than ever before. Under raking light, this texture produces some scintillating effects. Sullivan used this textural freedom throughout his career, creating some surfaces that sparkle. It will also be demonstrated that Sullivan changed his drawing style to better articulate his textural visions to others. The second way in which this dissertation looks at Sullivan's architecture is through the lens of Classical monumentality,

specifically that used in Donato Bramante's Palazzo Caprini (constructed ca. 1512), which is better known today as the House of Raphael. Composed of a basement surmounted by a major order, Bramante's venerable two-part pattern spawned legions of descendants. This dissertation will demonstrate that Sullivan applied lessons from derivatives of this structure's facade to a range of building types. Visual analysis of select building facades will demonstrate that Sullivan kept combining these two themes throughout his career. [Author Abstract]

81.) **Wahl, K.**
Fashioning the female artistic self: Aesthetic Dress in nineteenth-century British visual culture.
Ph.D. dissertation, Queen's University (Canada). 2004.

This dissertation investigates the cultural meaning of Aesthetic Dress in the activities and art production of individuals associated with the Aesthetic movement in Britain during the last four decades of the nineteenth century. During the 1870s and 1880s Aesthetic Dress was widely discussed in the fashion literature. At the same time, it was closely allied with the concurrent Aesthetic movement in the fine arts. This connection is evident through a survey of the fashion journals then circulating the term in connection with the visual arts and in the everyday usage of artistically-minded women, who wore Aesthetic Dress, attended and/or exhibited at the Grosvenor Gallery, and followed the work of the Pre-Raphaelites and J. M.

Whistler. This project traces the convergence between artistic practice, acts of self-fashioning, and gender-based manifestations of power, pleasure, and social change within a broader Victorian milieu. Aesthetic Dress played a crucial role in the self-definition of artistic elites. Reshaping the dominant stylistic traits of clothing in favour of looser more romantic forms of dress, Aesthetic Dress was not only designed and worn by members of the Aesthetic movement, but also utilized as a form of artistic inscription in the art produced at that time. It was expressive through a language of bodily gestures, historical referents and effects of drapery, form, and colour. Aesthetic Dress was also inflected by competing discourses of health and morality which characterize the dress reform movement during the second half of the nineteenth century. I also address the absorption of alternative modes of artistic dressing into mainstream fashion in the context of popular

culture. My research, by focusing on the social significance of alternative forms of dress in relation to both art and culture, redefines and historically situates Aesthetic Dress as a meaningful category in the history of visual culture, rather than examining it solely as a function of artistic elitism, or as a by-product of material culture. [Author Abstract]

82.) **Wark, J. M.**
The radical gesture: Feminism and performance art in the 1970s.
Ph.D. dissertation, University of Toronto (Canada). 1997.

This study examines the relationship between the insurgent feminist movement and the development of feminist performance art in North America during the 1970s. The thesis argues that feminist performance was instrumental in challenging the premise that art is an autonomous activity separate from the social and political conditions of everyday life. By adapting the feminist axiom that the personal is political to the practice of art making, feminist artists used performance as a form of cultural intervention in which personal experiences, narratives and representations were drawn upon to contest the prevailing social and political arrangements of gender. In so doing, feminist performance artists played a decisive role in reshaping our understanding of the political and in redefining the relationship between art and

politics during this period. This thematic study of the origins and development of North American feminist performance within the larger cultural context begins with an overview of the relationship between art and politics in the twentieth century. It traces the ideological shifts that account for the transformation of avant-garde art from a highly politicized to a primarily aesthetic movement in the two decades after World War II, which in turn resulted in a dilemma for many artists as they questioned whether their art could or should engage with the deepening social and political crises of the 1960s. This study goes on to establish how the rise of the feminist movement provided women artists with a means to re-engage art as a political practice. It explores the relationship between feminist politics and the formulation of performance as an art form particularly suited to the needs of feminist artists to reach new audiences and use their art as a weapon to renegotiate their role within the art world and to confront the oppressive effects of sexism in the

larger culture. Through discussion of an extensive range of works by individual artists in relation both to contemporaneous and more recent feminist theory, this study seeks to account for the specific ways in which feminist performance art has fundamentally altered our current understanding of aesthetic practice in relation to the social and cultural conditions in which it is embedded. [Author Abstract]

83.) **Watson, S. C.**
Servant of beauty: Willa Cather and the Aesthetic movement.
Ed.D. dissertation, Texas A&M University - Commerce. 1999.

The Aesthetic movement of the nineteenth century greatly influenced many turn-of-the-century writers, and among them is the American writer, Willa Cather. The central tenet of the movement--that art should be loved and enjoyed for its own sake and only for the sake of its beauty--may be seen in her writings, from her early years as a journalist to the works of her short stories and novels. Her particular mentor in the understanding of art for art's sake appears to be Walter Pater. This dissertation shows how Pater's ideas about art for art's sake are dealt with in The Troll Garden, her earliest published book of short stories; in The Professor's House, the novel of her middle years; and in Death Comes for the Archbishop, a story of the man who restructured the Diocese of New Mexico and built the cathedral in Santa Fe. This

study tracks Cather's artistic development from a disciple of art for art's sake--her search for beauty--through disillusionment with that philosophy, to her renewal of faith that, for her, was the ultimate and logical outcome of her life's journey. Included in the dissertation is a pedagogical chapter in which an interdisciplinary course is proposed and outlined. In the course, students trace the philosophy that led to the art for art's sake movement, investigate the historical and social setting in which the movement thrived, and read some of Walter Pater's works, some of Oscar Wilde's, and, of course, Willa Cather's short stories and novels that are discussed in this study. Cather knew that art and religion are very closely related; however, she moved beyond their relationship, discovering that love of beauty can lead to a love of God. Cather, along with Gerardus van der Leeuw, learned that "He [or she] who serves beauty serves God, at least if he serves faithfully." [Author Abstract]

84.) **Weiner, H.**
The doctrine of the image: An analysis of Pound's Imagisme and its bipolar aesthetic of the image.
Ph.D. dissertation, Stanford University. 1990.

"The Doctrine of the Image" analyzes the meaning of Pound's "Doctrine" for Imagisme, his first modern aesthetic movement, and for his poetics thereafter. It concentrates, initially, on the moment of Imagisme- -published as what he called The Platform of the Image in Harriet Monroe's Volume I of Poetry magazine. My dissertation stays closely with this Platform, which I believe guides the development of the poetic beyond its origination point: I contend the Platform presents two versions of the image which diametrically oppose one another, the three tenets of Imagisme, and the Doctrine of the image, respectively. The tenets are objectivist and are publicized, as they represent Pound's choice for modernizing the poem in the linguistic sense. Most Pound scholarship to date which has explicated the Imagisme moment has

read Pound's image as the objective image, the Utopian image free of excess verbiage. But the Doctrine has gone virtually ignored, except for the occasional allusion to it. It is my view that it reflects the opposing allure--for Pound--of a subjectivized image. I devote the majority of the dissertation to proving this thesis of bipolar sympathies and to exploring their theoretical ramifications, as the radically objective image is propounded because of a real belief in the possibility of referential language, a belief I discuss against the backdrop of current theory of language; while the subjective image is gradually liberated in moments of self-reflexive eruptiveness. [Author Abstract]

85.) **Weninger, S.**
The contagion of life: Rossetti, Pater, Wilde, and the aestheticist body.
Ph.D. dissertation, The Ohio State University.
1999.

Many studies of the Aesthetic Movement still presume it was fundamentally an idealist over-evaluation of art. It has even been stated that the logical consummation of its premises is not only an unethical ahistoricism but fascism. This dissertation argues that these cultural productions, highly responsive to the new biologies, focused on the human body. As such, Aestheticism was no ivory-tower cult of art, but a gesture of ideological rebellion against the era's underlying myths of determinism and human perfectibility. Chapter one demonstrates how Rossetti's "Jenny," an interior monologue of a scholar before a sleeping prostitute, foregrounds the body as such and how it subverts the courtly love tradition Rossettian texts seemingly support. The next chapter argues that the painting Dantis Amor similarly

dramatizes the lover's melancholy before the intransigent body. Chapter three, a broad reading of Pater's texts, contends that his numerous images of malady and his various grotesquerie are central to his materialist aesthetics. His short story, "Sebastian van Storck," studied in corporeality. Chapter five discusses the early modernist turn towards a healthy, masculine aesthetic, against Aestheticism's "decadent" and "effeminate" art. This reactionary strain is discerned in the new Glaskultur , from avant-garde manifestoes to fictional texts like Herbert Read's The Green Child . The important issues of social ideology raised here are the subject of the remaining pages. First, I explore the neglected links between Victorian Hellenism, the ascendant theories of "Aryanism," and Prussian classicism. The Aestheticist body, I suggest, was an ignored counterweight to this fantasized affiliation or imagined anatomy which would play a crucial role in the barbarity of the fascist biocracy. The final chapter contrasts the depth model of the

body which structures nineteenth-century idealism, high modernism and fascist aesthetics with the palimpsest model favored by Rossetti, Pater and Wilde. Aestheticism attempted to work out a poetics (and by implication a politics) of the diseased, heterogeneous body as opposed to the "healthy" and "transparent" Victorian body which found new life in early modern thought and ultimately in the corporeal politics of fascism. [Author Abstract]

86.) **Yount, S. L.**
"Give the people what they want": The American aesthetic movement, art worlds, and consumer culture, 1876-1890.
Ph.D. dissertation, University of Pennsylvania.
1995.

This dissertation examines the cultural politics of the American Aesthetic movement in terms of the increasing professionalization of the New York art world and the expanding consumer marketplace. A self-consciously meliorist and didactic movement grounded in the belief that a 'beautiful' environment could promote moral and social change, Aestheticism played a significant and complex role in the transformation of late nineteenth-century American culture and ideologies. Revealing the relationships between artistic design, social reform, and consumption through a close analysis of myriad 'fine' and 'popular' visual and textual materials, I explore the layered meanings of Aestheticism as a progressive and nostalgic impulse that both critiqued and reinforced the dominant social

order. By understanding consumption as a rich cultural enterprise central to the dual processes of class identity and lifestyle formation, the study argues that American Aestheticism's particular language of reform made it readily adaptable to the nascent consumer ethos, a development that not only generated widespread popularity but, ultimately, decline. [Author Abstract]

87.) **Yu, T.**
The sociology of the avant-garde: Politics and form in language poetry and Asian American poetry.
Ph.D. dissertation, Stanford University. 2005.

Language poetry and Asian American poetry, two modes of contemporary American writing, can both be seen as avant-gardes, aesthetic formations that are simultaneously conscious of themselves as social formations. Their shared origins, and the reasons for their divergence, demonstrate how race, gender, and class inflect aesthetics. Allen Ginsberg's poems of the late 1960s, dictated into a tape recorder while driving cross-country, seek to combine the media's generalizing power with individual consciousness, but reveal an uncertain, self-revising subjectivity. Language writer Ron Silliman extends Ginsberg's vision of a documentary poetry, but employs formal techniques that guard against Ginsberg's excesses of subjectivity. Silliman adapts to the political context of the 1970s by positing

Language writing not simply as an aesthetic movement but as a social identity. Silliman's first major work, Ketjak, is both a convincing map of the social landscape and an uncomfortable exploration of white male consciousness. Asian American poetry of the 1970s engaged in comparable struggles over identity and poetic form. The work of such poets as Janice Mirikitani, Francis Oka, and Lawson Fusao Inada reflects a dynamic fusion of Beat, jazz, and populist influences. But during the 1980s, as Language and Asian American writing gained mainstream visibility, their practices came to seem radically separate. The reception of Theresa Hak Kyung Cha's Dictée, neglected by Asian American critics until the 1990s, illustrates the avant-garde continuity of Language and Asian American writing, but also cautions against any simple attempt to integrate the two. The multiple and often conflicting structures that organize Dictée make it a text in which the impulses of experimental and Asian American writing meet in mutually critical fashion. By the

1990s, the term "experimental Asian American poetry" had emerged to describe work like Cha's. But the writing of John Yau, far from providing such a synthesis, stages the history of and conflict between these contemporary avant-garde modes. In hanging on to the emptied-out structures of ethnic identity, Yau gains a foothold from which to critique Language poetry's attempt to incorporate the "marginal." [Author Abstract]

88.) **Zuelsdorf, D. L.**
Implications of creativity, artistic expression, and psychological cohesion: The self-portrait as a reparative selfobject of Egon Schiele.
Psy.D. dissertation, The Chicago School of Professional Psychology. 1995.

Mystery surrounds the mechanisms of creativity. Psychoanalytic theory attempts to explain the psychic mechanisms that drive the creatively endowed individual toward expression of internal fantasies, dreams, and perceptions of reality. The author explores theories of creativity within published psychoanalytic literature and selects self psychology as a preferred approach to study the dynamics of a turn-of-the-century Viennese artist, Egon Schiele. Creativity, long recognized for its potential to forestall fragmentation of the self, influences the movements of groups and nations as well. Self psychology views creativity as a medium of reciprocal effects, altering narcissistic states of the artist as well as the audience, which is regarded as a vicarious participant in the creative work. The chronology

of self-portraits painted by Schiele offers a unique opportunity to examine theories of narcissism from the self-psychological perspective of Kohut. Viewing narcissism as a positive symbol of development, a healthy constituent of the nuclear self that interacts with the external world, self psychology offers a comprehensive view of the artist's struggles with both internal and external phenomena. As an element of narcissistic equilibrium, particularly among artists, creativity supplies the creative individual with a private means of self-restoration. Schiele's chronological execution of self-portraits demonstrate the narcissistic needs of both grandiose-exhibitionism and idealistic merger with imagery of the self and significant others. The highly narcissistic Schiele sought to fill structural deficits in the self through manipulation of his pictorial image in the forms of artistic studies and allegory. This study examines the healthy narcissistic fulfillment achieved by Schiele as his work drew severe critical judgment from Viennese traditionalists.

Risking highly cathartic appraisals by the public, his overpowering needs for self-cohesion compelled him toward nude expositions depicting both physical and metaphysical angst. Drawn to self-portraits as a self-integrative mechanism, following a childhood immersed in family trauma and struggles with death, disease, insanity, and economic hardship, Schiele's most intense works emerged during the period of Freud's self-analysis. A self psychological examination of Schiele's intrepid journey through self-revelation, self-discovery, and integration of split-off parts of the self illustrates the worth of self psychology as a theory that accounts for the importance of assessing cultural effects upon the individual. Schiele assumed a major role in a regional aesthetic movement intent upon revealing the angst and struggle of the individual, opposing the long-held cultural mores of Victorian Vienna, which were embedded in sociopolitical glamour and facade. Austrian Expressionism, eventually tied to an internationally known movement of German

Expressionism, played an integral role in a philosophical and cultural paradigm shift centered in Vienna, fashioning sociocultural fantasies of bourgeoisie philandering toward into harsh images of human reality. Schiele's own internal struggles both prompted and aligned with cultural change, endowing his work with a disturbing, yet meditative sense. Using his tremendous creative endowment, Schiele entered into a life-long, narcissistically driven process of self-reflection and self-analysis that equally exposed repressive social and cultural values of Vienna and Europe. [Author Abstract]

Locating Dissertations and Theses

A. Purchase

Many of the dissertations and theses listed in this bibliography are available for purchase through UMI Dissertation Express:

http://disexpress.umi.com/dxweb

By Fax:

800-864-0019

By Mail:

789 E. Eisenhower Parkway, P.O. Box 1346, Ann Arbor, Michigan 48106-1346

800-521-3042

B. Interlibrary Loan

Dissertations and theses may also be requested through Interlibrary Loan via your local public, college or university library.

www.ingramcontent.com/pod-product-compliance
Lightning Source LLC
Chambersburg PA
CBHW071404170526
45165CB00001B/180